AUTUMN

A U T U M N

JEAN MULATIER

RIZZOLI

First published in the United States of America in 2004 by

Rizzoli International Publications, Inc.
300 Park Avenue South • New York, NY 10010 • www.rizzoliusa.com

2004 2005 2006 2007 2008/
10 9 8 7 6 5 4 3 2 1
ISBN: 0847826392
Library of Congress Catalog Control Number: 2004108224

Designed by Paul Kepple and Jude Buffum @ Headcase Design • www.headcasedesign.com

Printed in the United States

Whenever I saw photographs of Canadian forests in autumn, I would think such colors were impossible; they must have been enhanced. Then I went to see for myself. There, in person, the colors were ten times more beautiful—a treat for the eyes!

European autumns are generally monotonous. The weather is gray and the color of the foliage barely varies from ocher to brown. By late summer, the leaves are often dried out, particularly if the heat has been intense. Any yellows and reds are mere accents. And while this palette may have a certain wistful charm, it has nothing in common with the fireworks of a North American autumn, when the leaves challenge even the flowers with their outrageous display of colors.

The oak leaves of the Old World are utterly discreet, but on this side of the Atlantic they blaze red and scarlet. The canoe birches, hickories, sassafras, and honey-locusts flame no less gloriously. The pin oaks are an exception: just to be different, they turn a bright golden yellow. Every part of the forest glows in sequence: the sumacs, mountain ash, bilberries.

The maples, too, seize this opportunity to declare their burning passion to the blushing Virginia creeper. Faced with their festival of colors, the first botanists seem to have run out of adjectives: red, black, striped, and silver maple trees. The dozens of dominant species would have sufficed to transform Europe and Verlaine's *"sanglots longs des violons de l'automne" ("long sobs of the violins of autumn")* into a resounding symphony for woodwind and brass, ringing with a thousand lights in the blue, Indian summer sky. During the brief warm spell that sometimes occurs in the fall, the alternation of sunny days and very cool nights is the secret behind this miraculous chromatic alchemy that changes wood into gold.

Outside the zone comprising southeast Canada (Ontario and Quebec) and New England, you have to go to the other end of the world—Japan and Korea—to find the same climatic conditions,

largely determined by currents of cold air from the North Pole. Japanese autumns in particular are famous for their show. As far apart as Japan and America are, they have much in common. For example, in the first days of October, in both New England and Japan, foliage pilgrimages take place. The color worshippers come from everywhere, drawn by the gold. Yet they are not quite modern-day explorers: Cars are often their only means of locomotion, and many never think to get out and explore the woods on foot.

Little country roads host long, bumper-to-bumper motorized processions. Noses to the car window, passengers savor the multicolor swan song at ten miles an hour. This symphony of the maples is not to be missed, especially at its "peak," that brief moment of the year when the colors are at their richest. It lasts two or three days, or sometimes just a few hours if a gust of wind or a rain shower hastens the burial of leaves that are

not quite dead, but quite fragile due to night frosts and waning sap.

Photography makes it possible to stop time, to extend the moment of grace forever, by stopping the leaves' fall. And so autumn suspends its flight.

Yet, for all the technology available today, film is still powerless to render the full range of this superabundant palette. Sun-filled maple leaves backlit against sky blue look like Technicolor stars—captivating beauty that does not permit itself to be captured easily. A photograph on paper is always so much less brilliant than a slide, and a slide, so inadequate compared to the original subject!

The days get shorter; the sun, closer to the horizon. And now, for an instant, the sunset creates Hollywood-style backlighting, filtering through the sparse foliage to powder even the tiniest twigs with gold dust. It is no longer the photographer

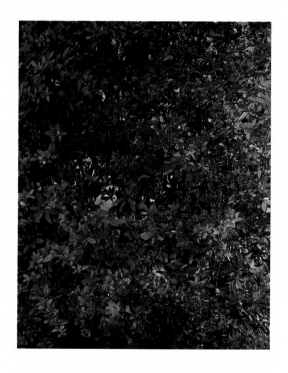

who shoots, but beauty itself which strikes him down. The sun always sets too soon for the pilgrim surprised in mid-ecstasy, stunned, unable to contain within a view-finder this wonder disappearing into darkness.

Dusk is the witching hour, when the photographer must gather all his resources and focus on the final visions, because this enchantment continues into the twilight, that magical moment when the wind falls, the surfaces of the lakes become mirrors, and the mirrors become kaleidoscopes that multiply the scenic splendor over and over again.

Night falls and the dreamer turns back, astounded, his Nikon bursting with unforgettable imagery—or at least so he hopes, as he hardly dares to go forward, walking lightly, for fear of sullying the sumptuously hued carpet of leaves beneath his feet.

Ultimately, it is not autumn that is sad, but the fact that it ends.

— J E A N M U L A T I E R

A LAKE IS THE LANDSCAPE'S MOST

IT IS EARTH'S EYE; LOOKING INTO WHICH

BEAUTIFUL AND EXPRESSIVE FEATURE.

THE BEHOLDER MEASURES

THE DEPTH OF HIS OWN NATURE.

— HENRY DAVID THOREAU

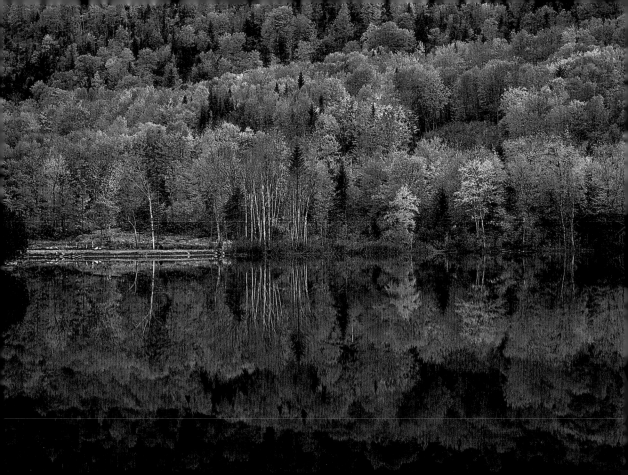

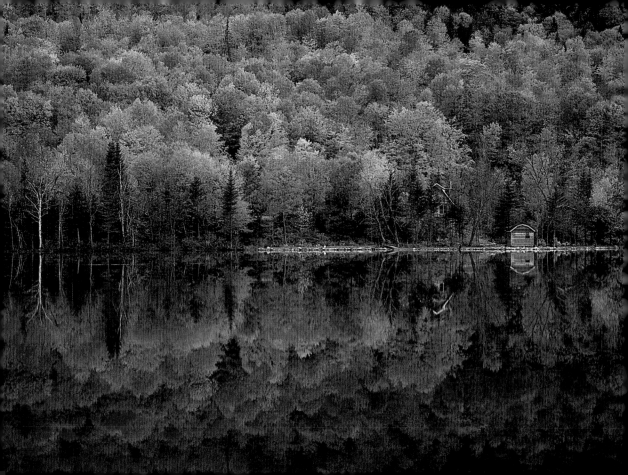

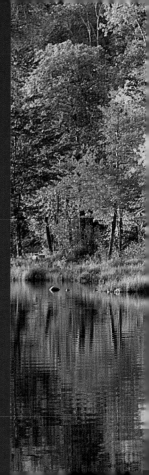

BEAUTY IS ETERNITY

GAZING AT ITSELF IN A MIRROR.

— KAHLIL GIBRAN

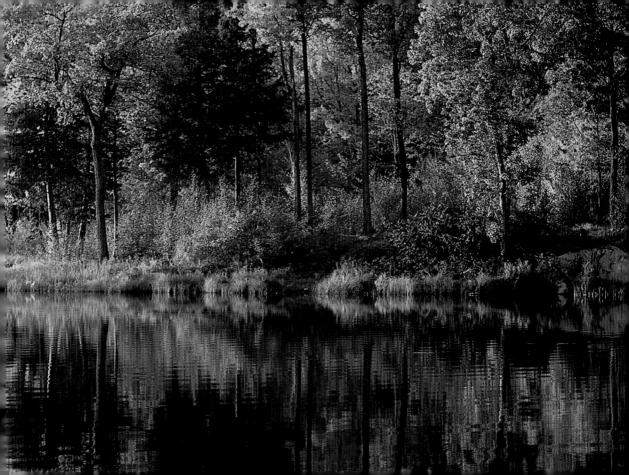

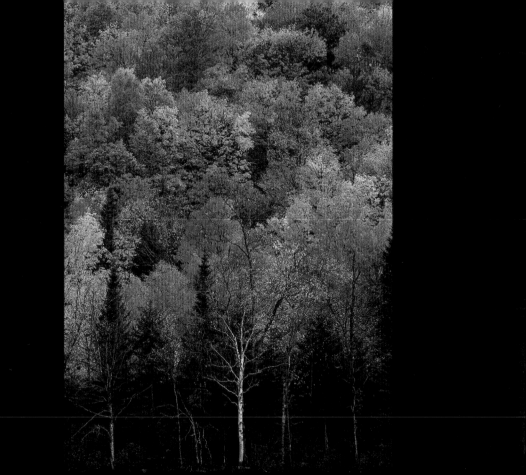

HERE MAN IS NO LONGER THE CENTER OF THE WORLD,

ONLY A WITNESS,

BUT A WITNESS WHO IS ALSO A PARTNER

IN THE SILENT LIFE OF NATURE,

BOUND BY SECRET AFFINITIES TO THE TREES.

— DAG HAMMARSKJÖLD

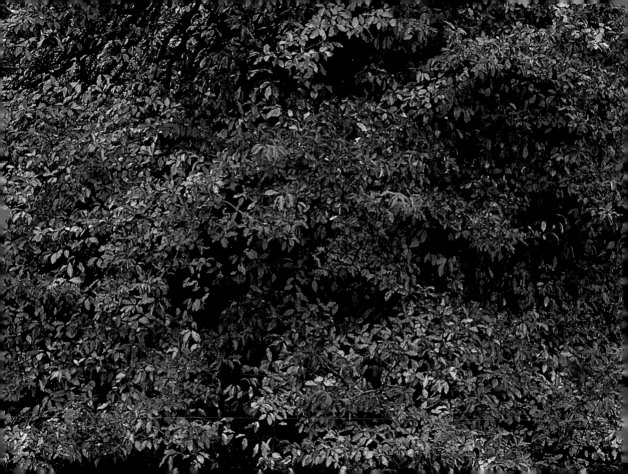

17

18

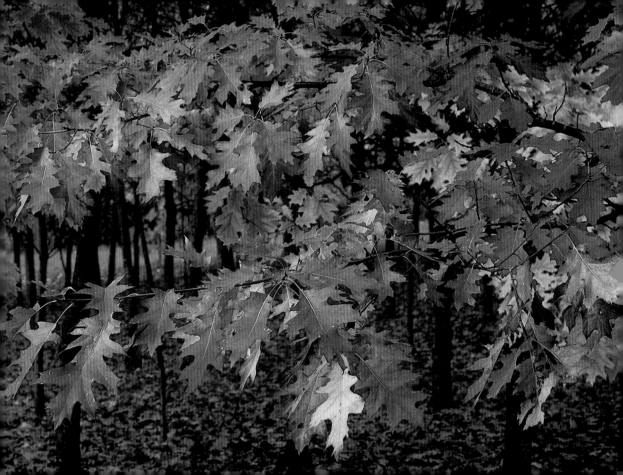

HOLY MOTHER EARTH,

THE TREES AND ALL NATURE

ARE WITNESSES OF YOUR

THOUGHTS AND DEEDS.

—NORTH AMERICAN INDIAN PROVERB

(WINNEBAGO)

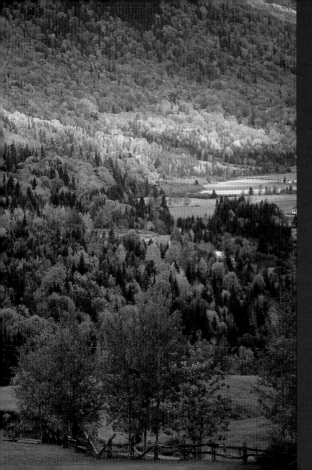

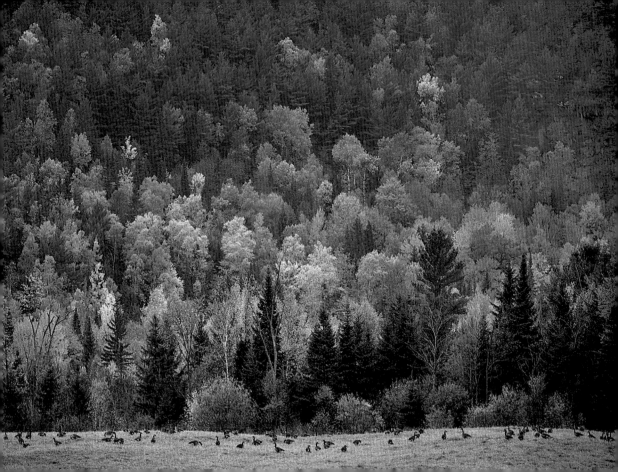

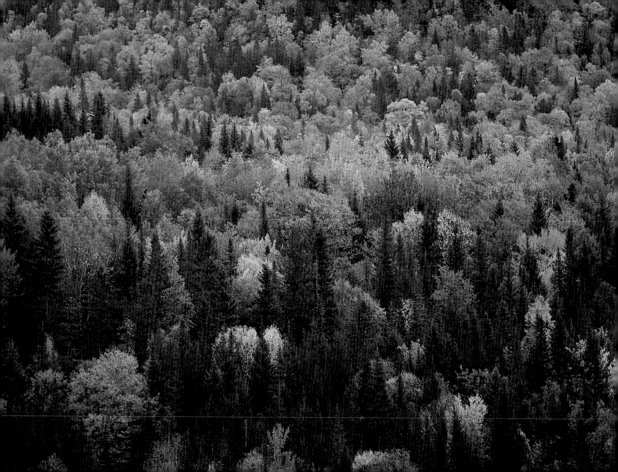

26

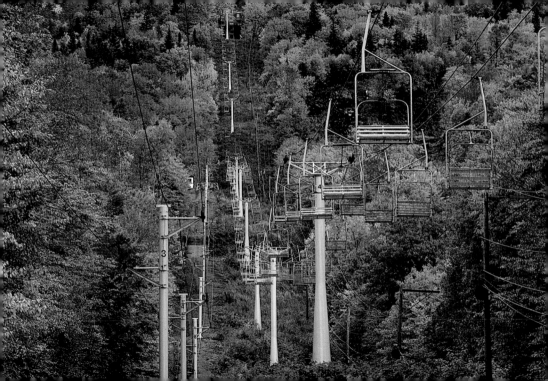

It is not the language of the painters
but the language of nature
—
which one should listen to.

—VINCENT VAN GOGH

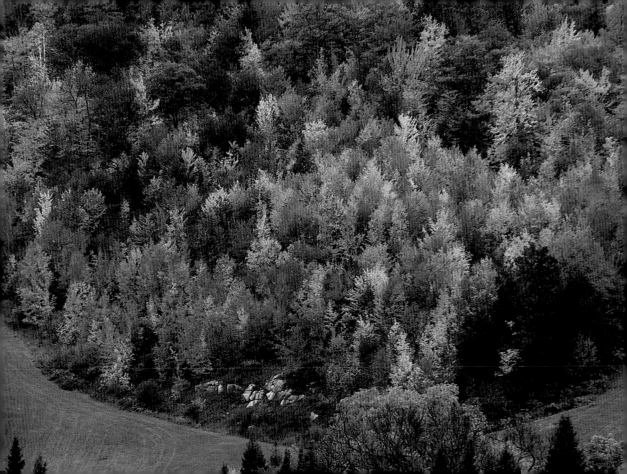

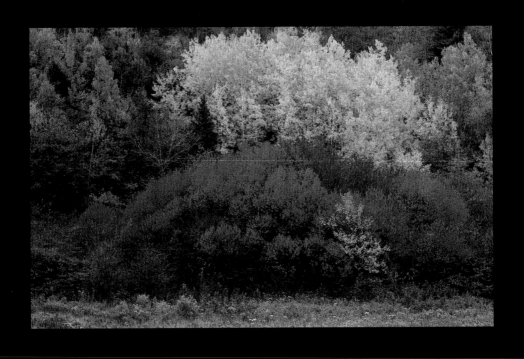

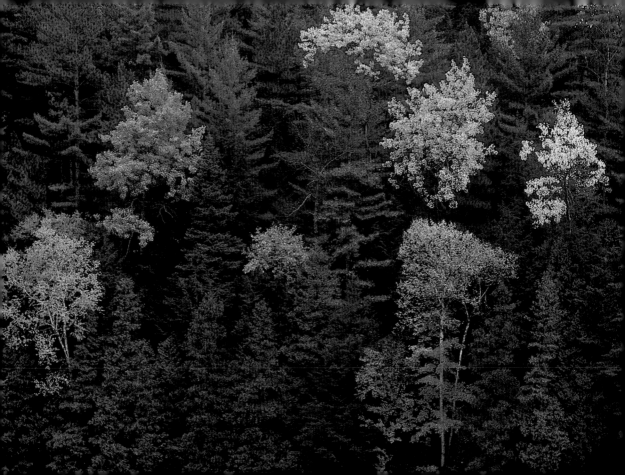

THIS IS THE FOREST PRIMEVAL.

THE MURMURING PINES AND THE HEMLOCKS...

STAND LIKE DRUIDS OF OLD.

— HENRY WADSWORTH LONGFELLOW

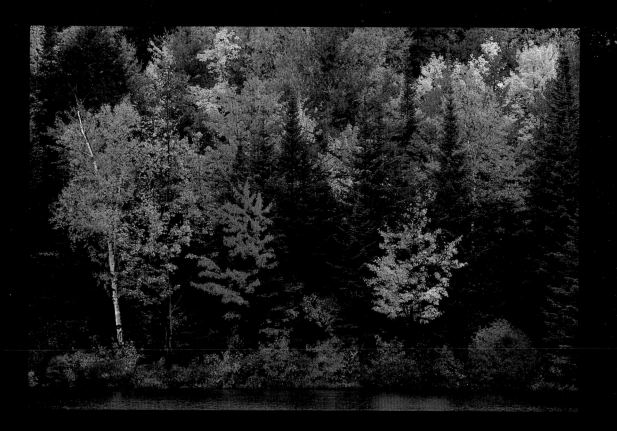

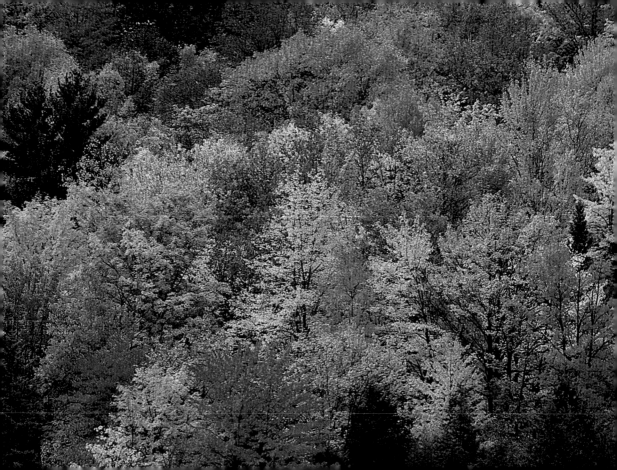

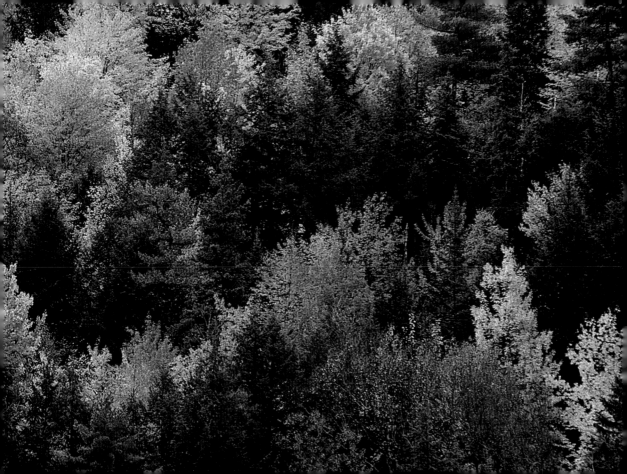

I LIKE TREES

 BECAUSE THEY SEEM MORE RESIGNED

TO THE WAY THEY HAVE TO LIVE

 THAN OTHER THINGS DO.

— WILLA CATHER

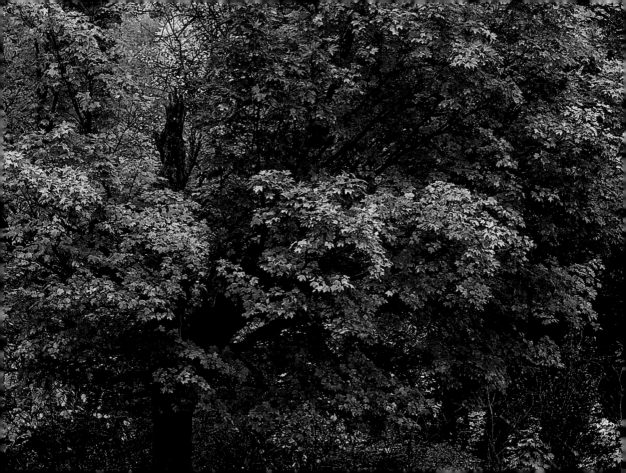

SILENCE IS THE PERFECTEST HERAL

I WERE BUT LITTL

OF JOY.

HAPPY IF I COULD SAY HOW MUCH.

— WILLIAM SHAKESPEARE

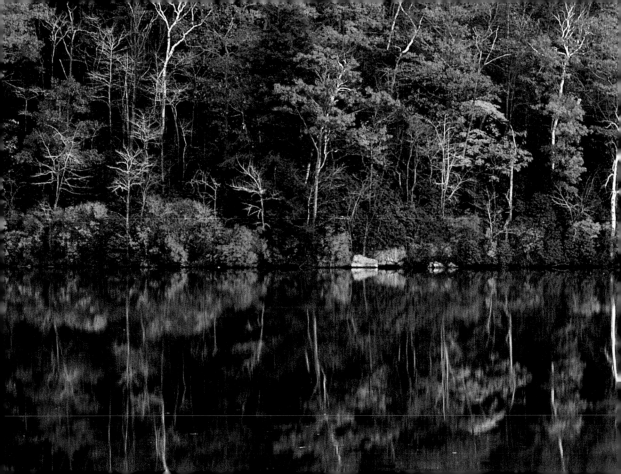

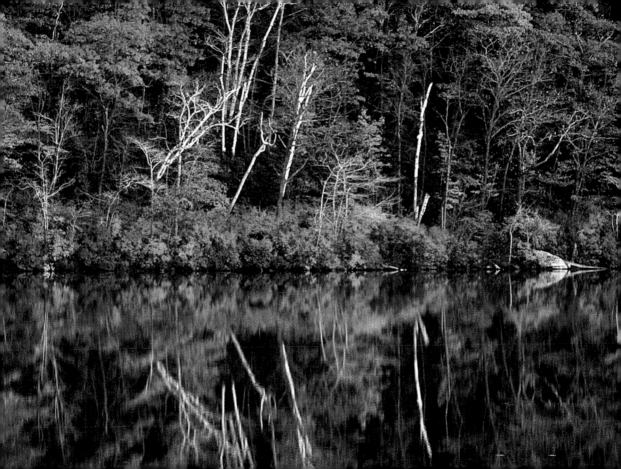

42

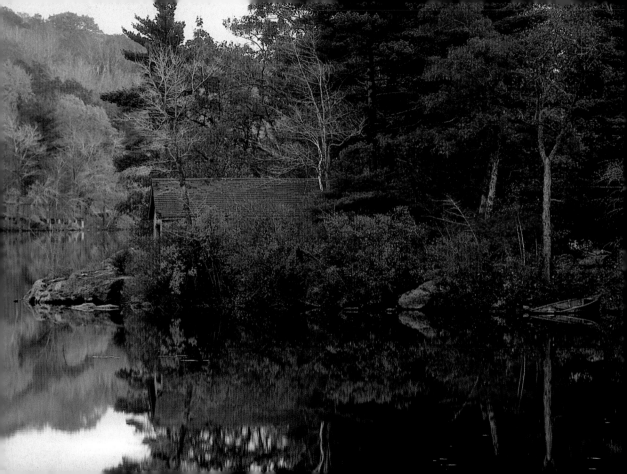

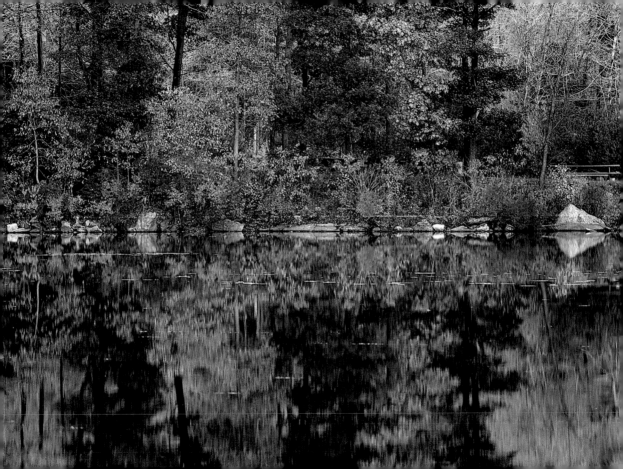

BEAUTY IS A SHORT-LIVED TYRANNY.

— SOCRATES

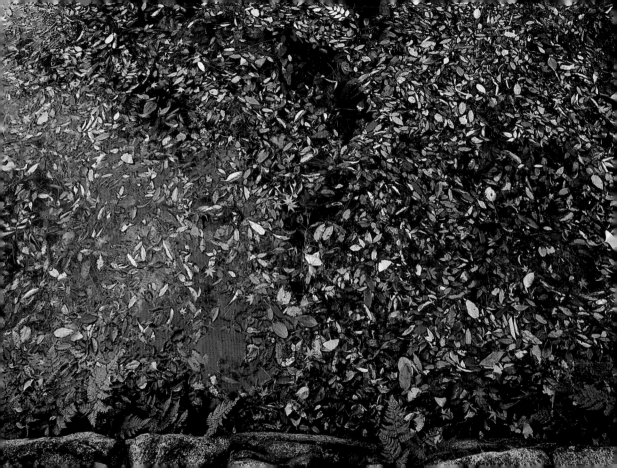

48

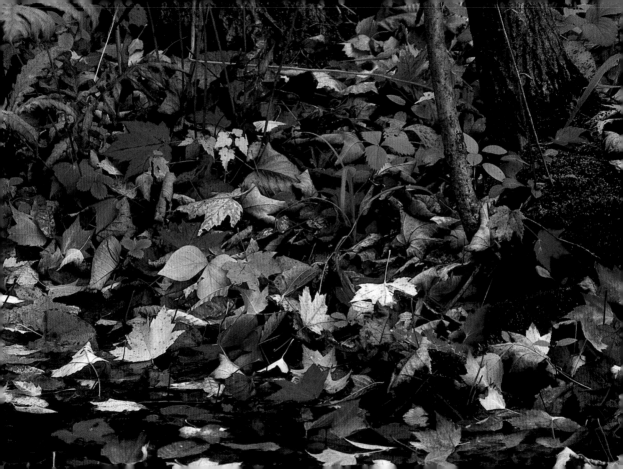

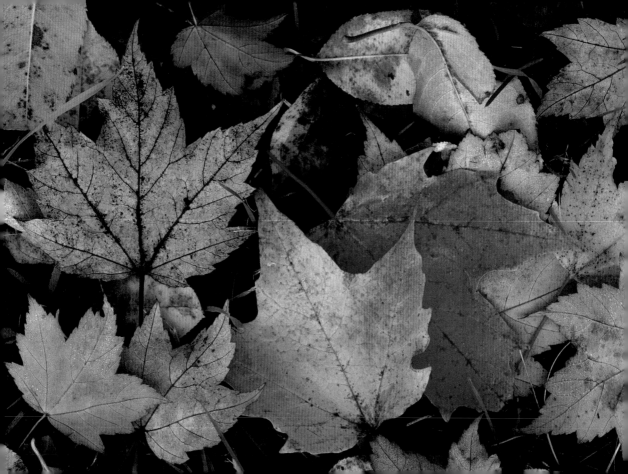

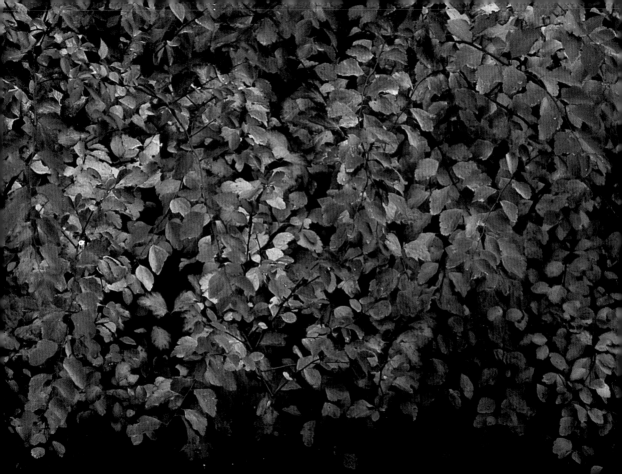

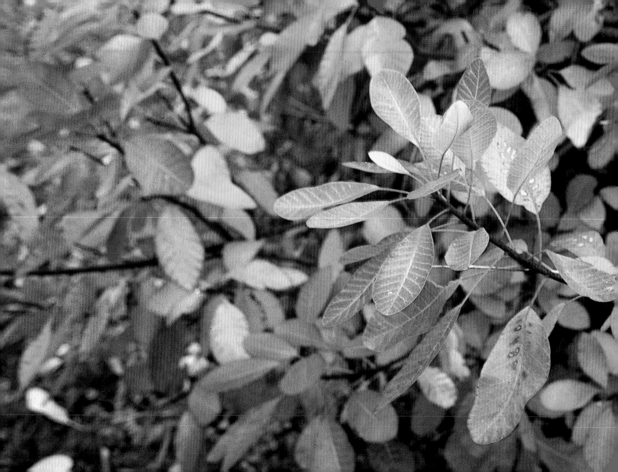

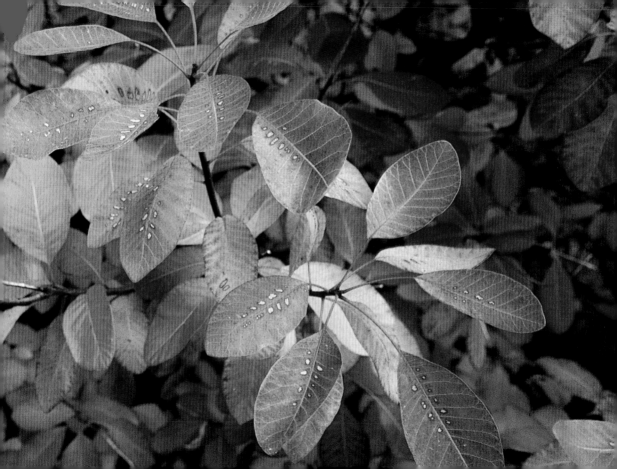

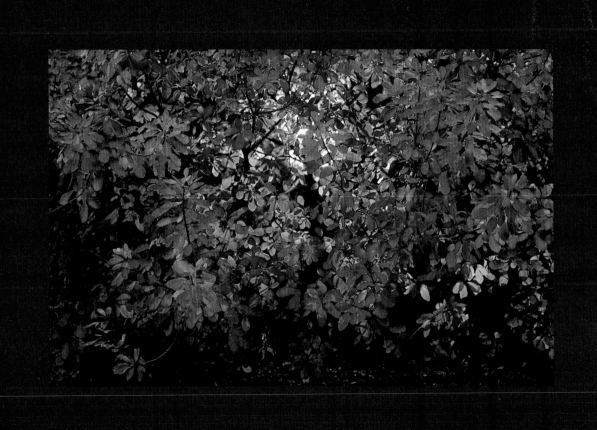

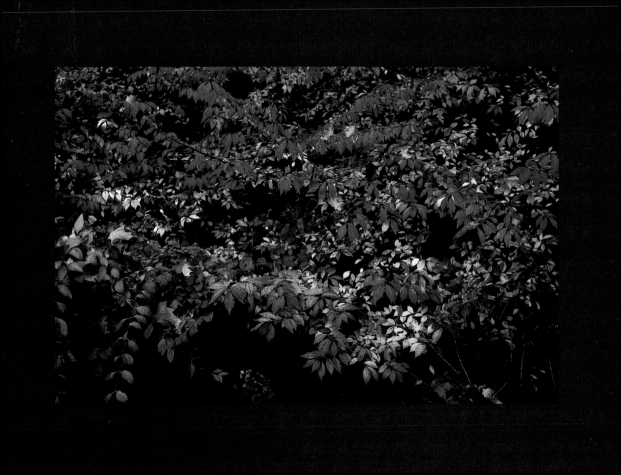

58

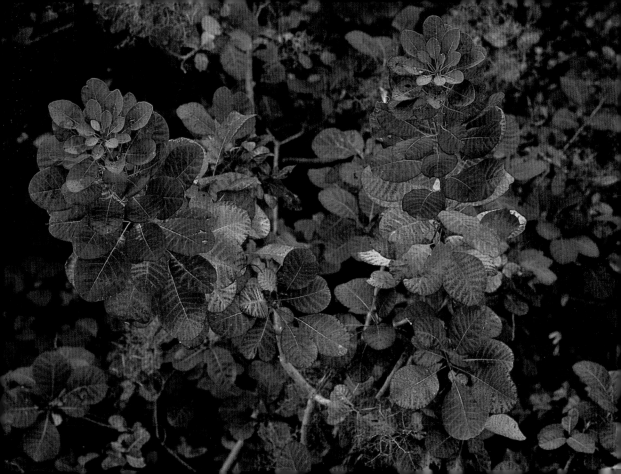

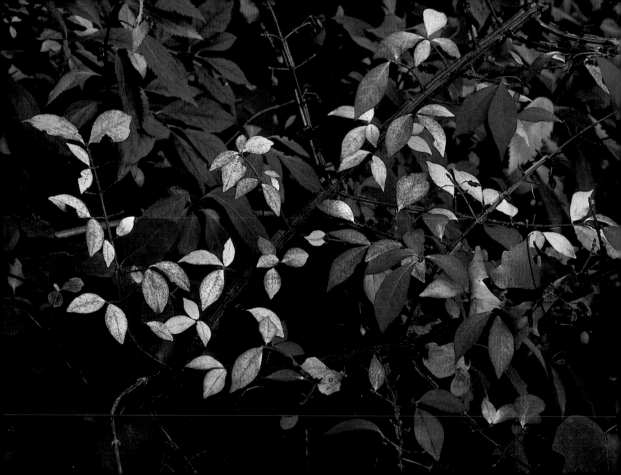

61

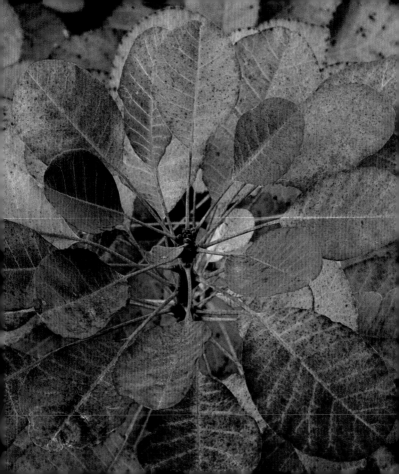

To THOSE WHO HAVE NOT YET LEARNED

THE SECRET OF TRUE HAPPINESS,

BEGIN NOW TO STUDY THE LITTLE THINGS

IN YOUR OWN DOOR YARD.

— GEORGE WASHINGTON CARVER

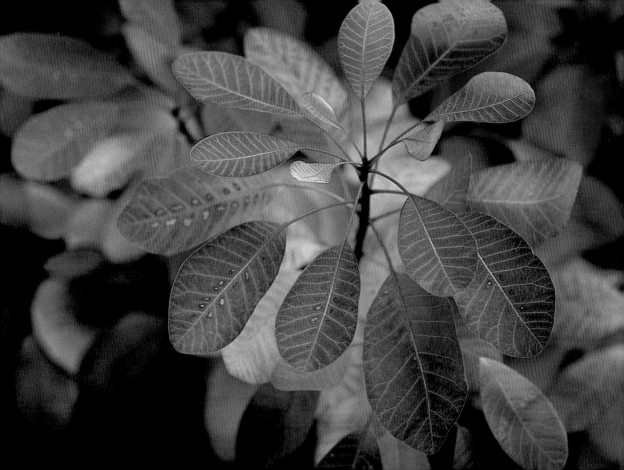

THE LEAVES OF MEMORY SEEMED TO

...AKE A MOURNFUL RUSTLING IN THE DARK.

—HENRY WADSWORTH LONGFELLOW

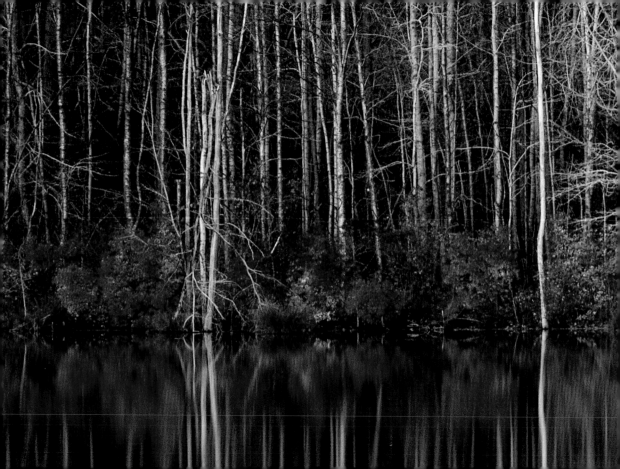

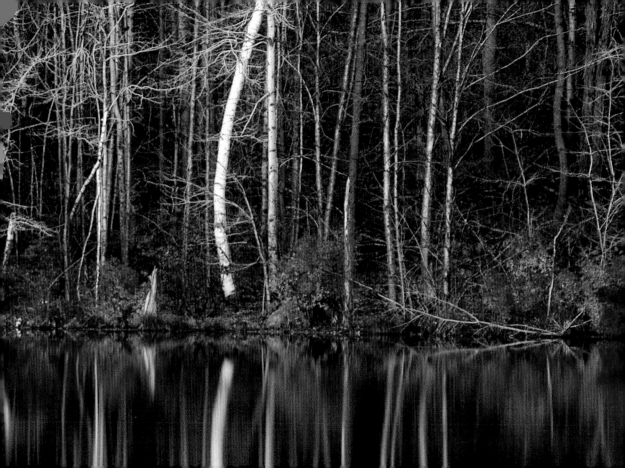

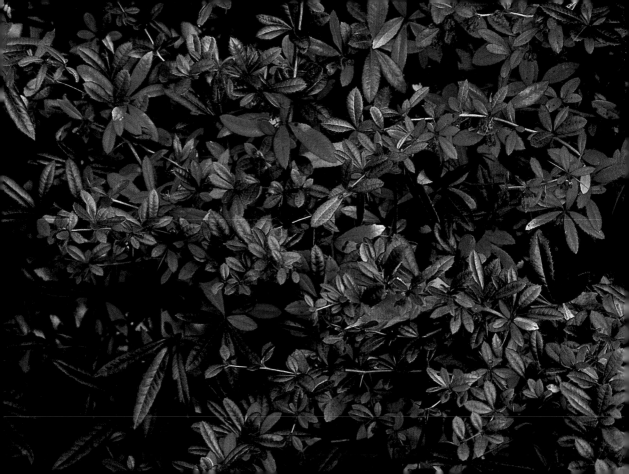

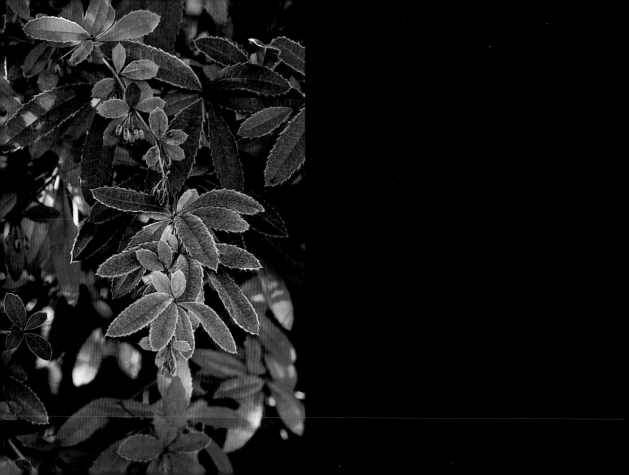

ALL CHANGES, EVEN THE MOST LONGED FOR,

HAVE THEIR MELANCHOLY;

FOR WHAT WE LEAVE BEHIND US IS A PART OF OURSELVES;

WE MUST DIE TO ONE LIFE

BEFORE WE CAN ENTER INTO ANOTHER.

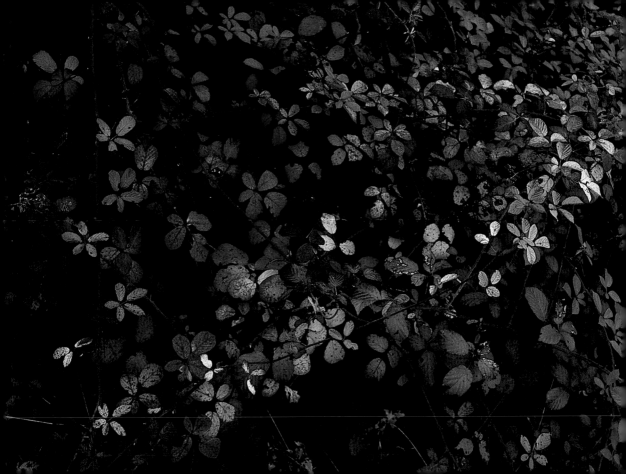

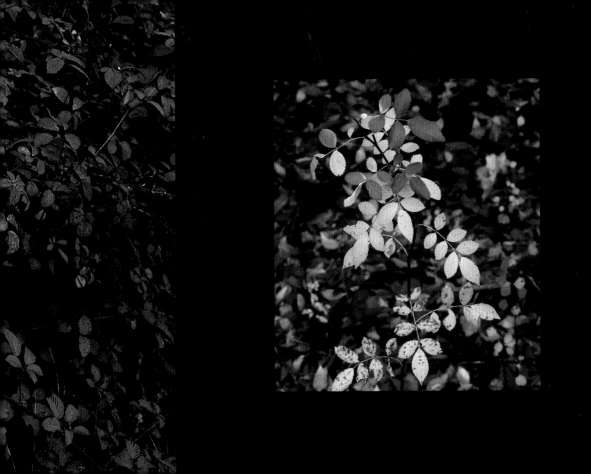

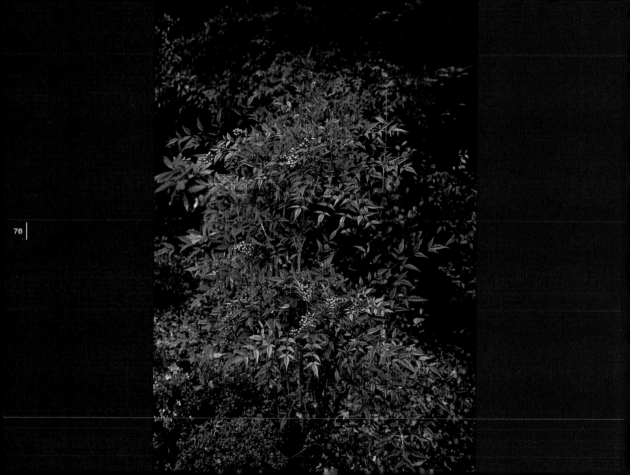

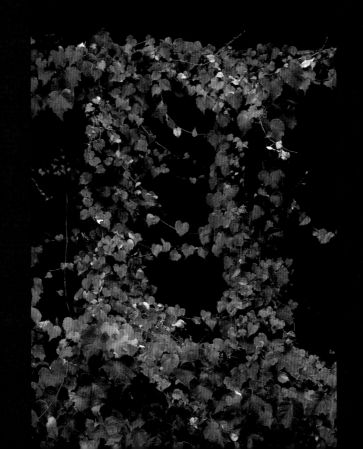

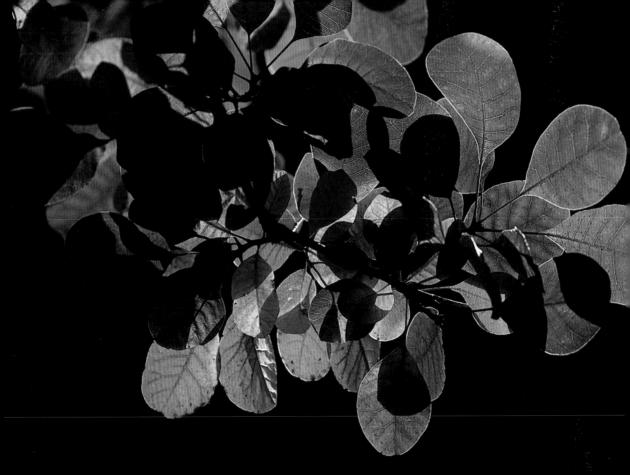

WE ALL

DO FADE

AS A LEAF.

—ISAIAH

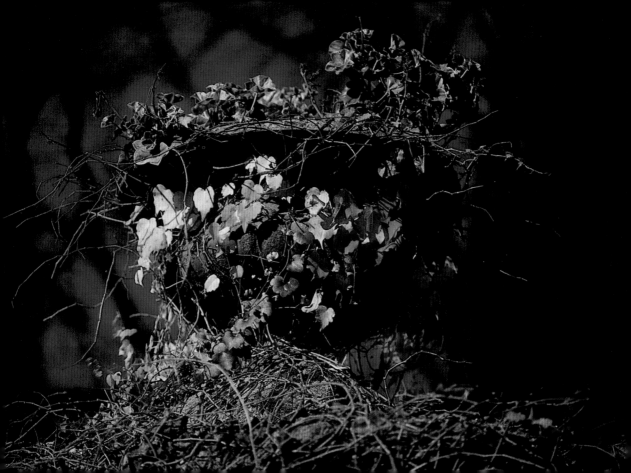

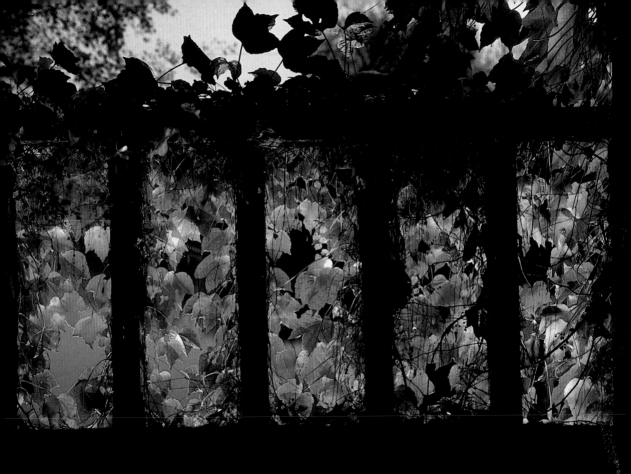

No spring, nor summer beauty hath such grace

As I have seen in one autumnal face.

— JOHN DONNE

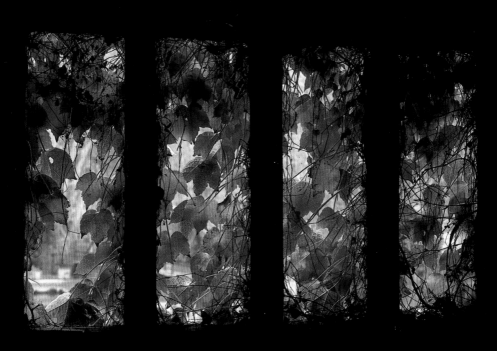

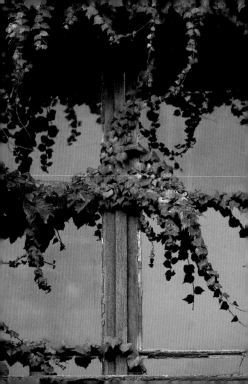

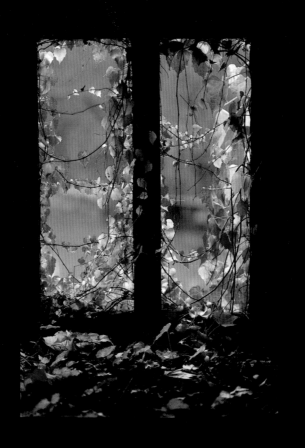

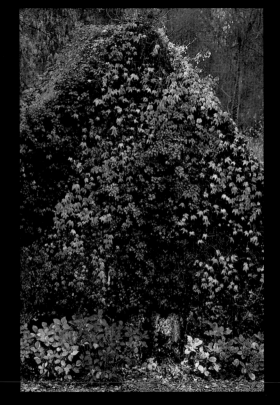

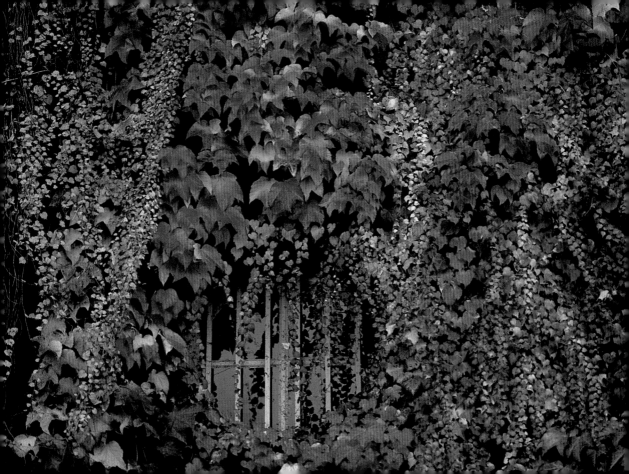

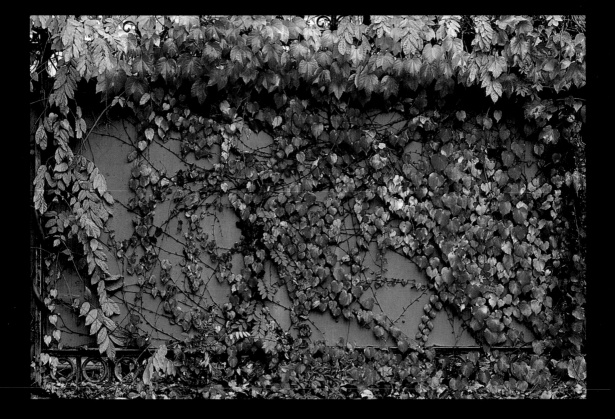

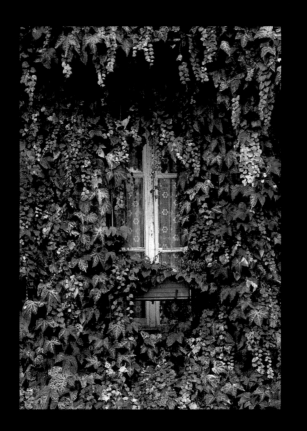

THE EVENING OF OUR LIVES

BRINGS WITH IT ITS OWN LAMP.

— JOSEPH JOUBERT

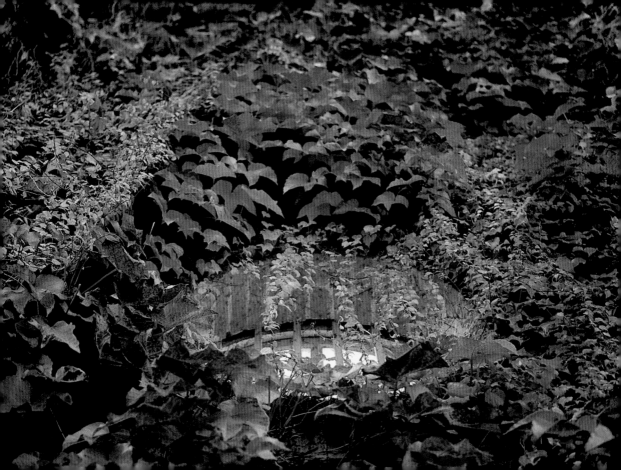

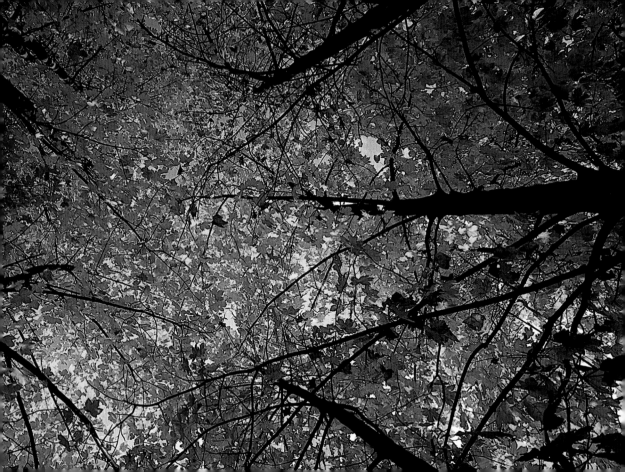

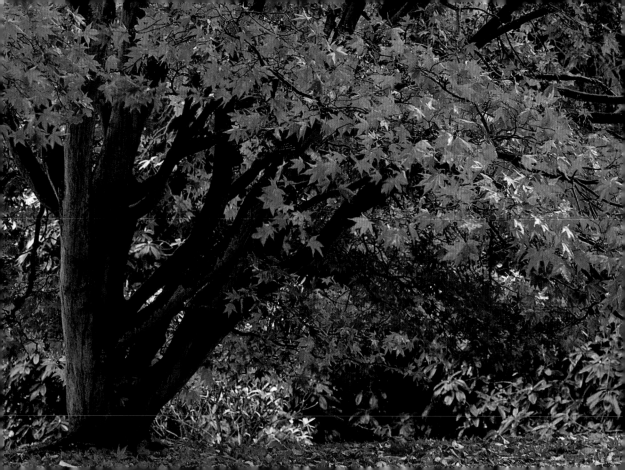

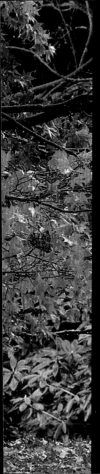

WHILE WITH AN EYE MADE QUIET BY THE POWER

OF HARMONY, AND THE DEEP POWER OF JOY,

WE SEE INTO THE LIFE OF THINGS.

— WILLIAM WORDSWORTH

98

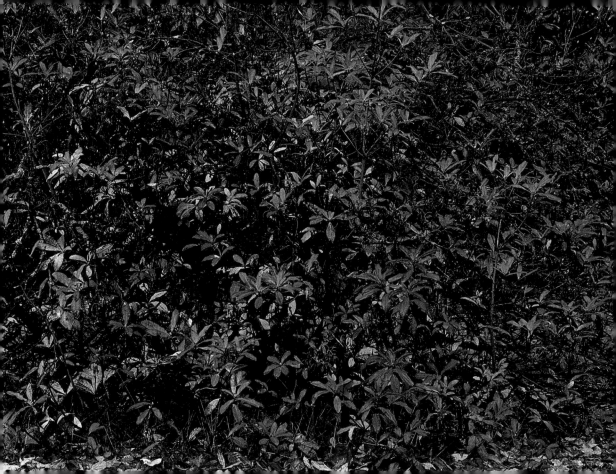

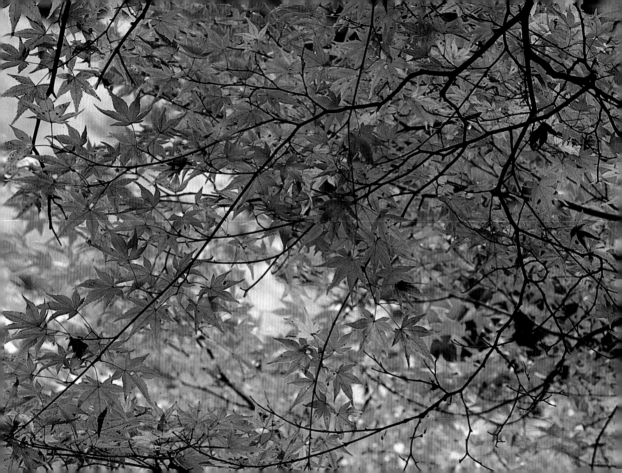

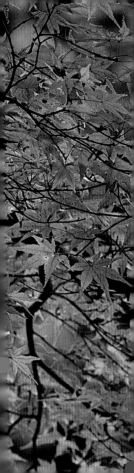

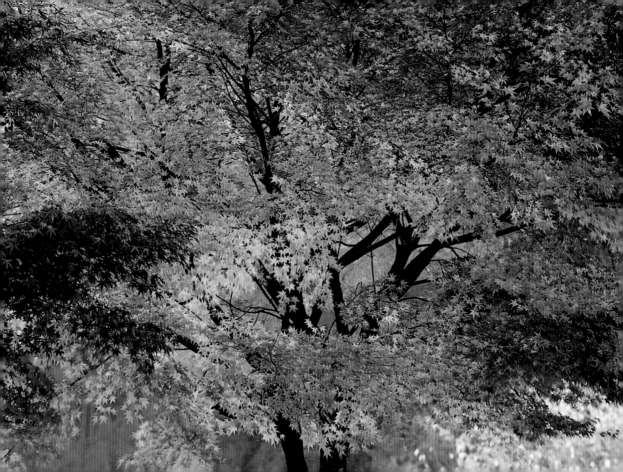

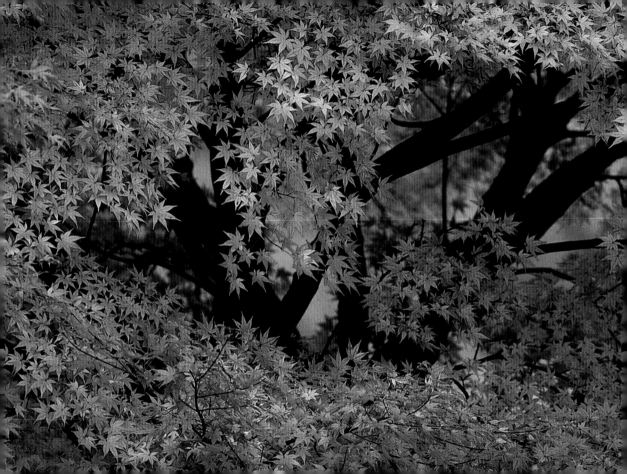

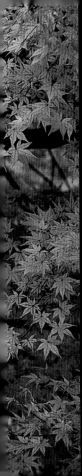

EARTH'S CRAMMED WITH HEAVEN,

AND EVERY COMMON BUSH AFIRE WITH GOD.

— ELIZABETH BARRETT BROWNING

106

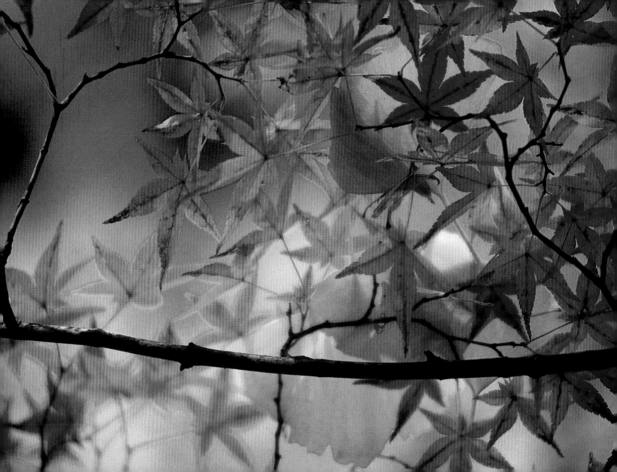

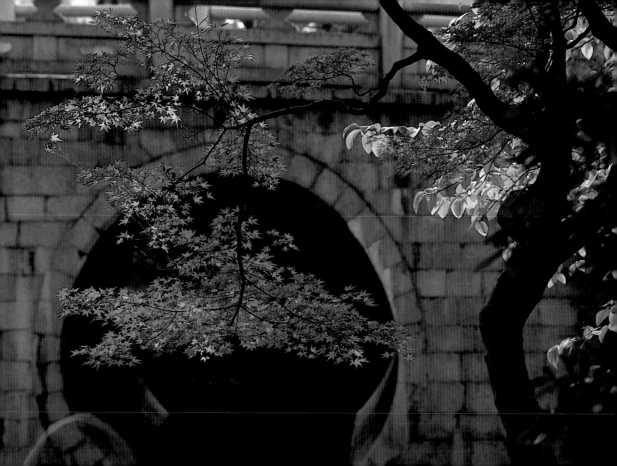

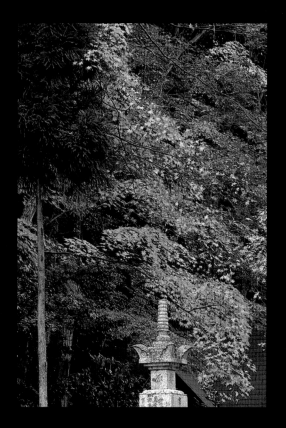

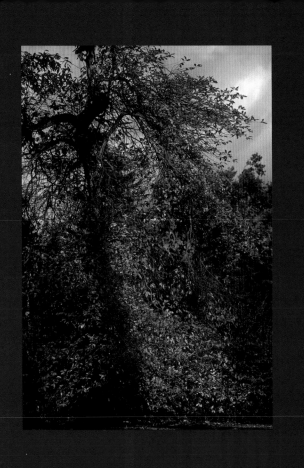
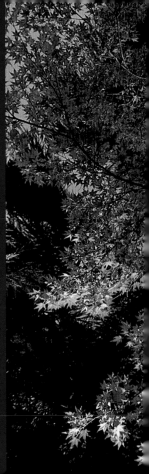

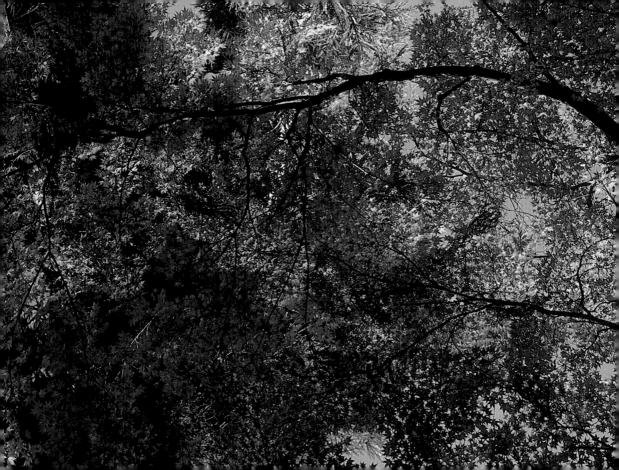

SPEAK TO THE EARTH,

AND IT SHALL TEACH THEE.

— JOB

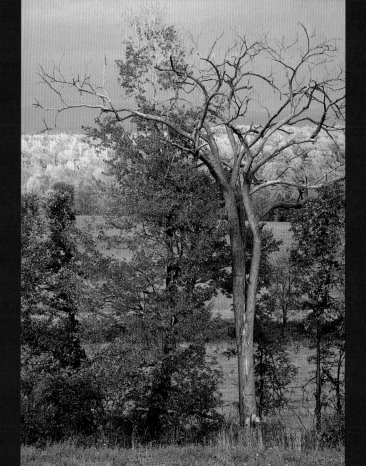

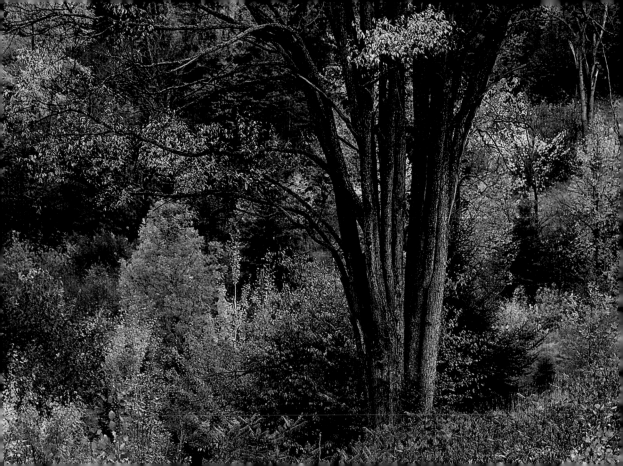

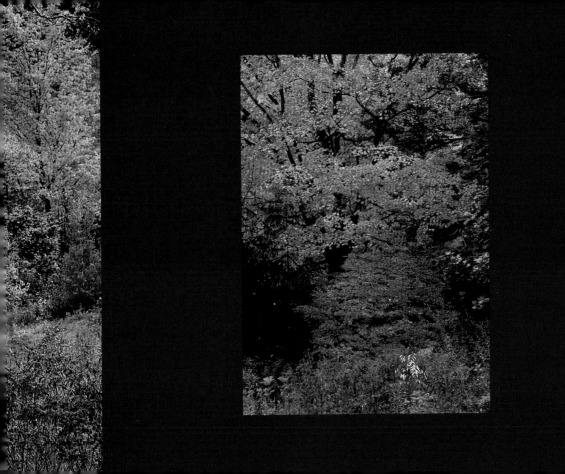

DAYS DECREASE, AND AUTUMN GROWS,

AUTUMN IN EVERYTHING.

— ROBERT BROWNING

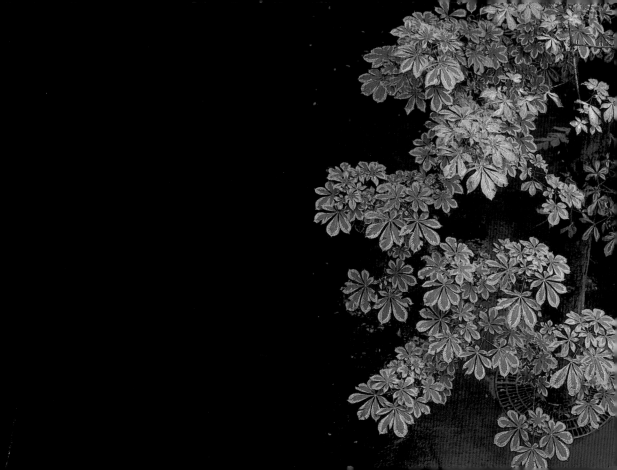

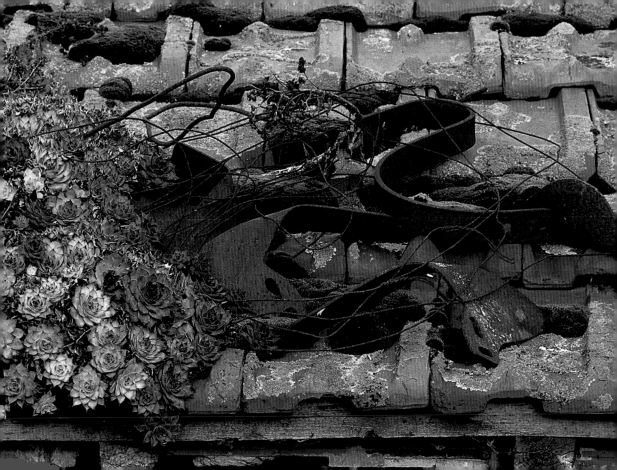

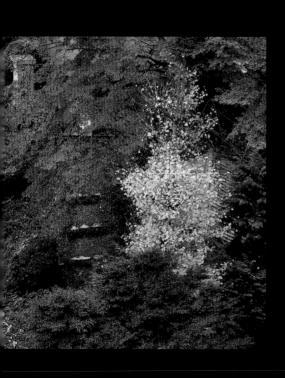
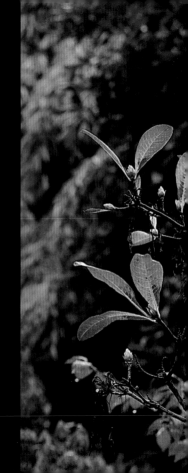

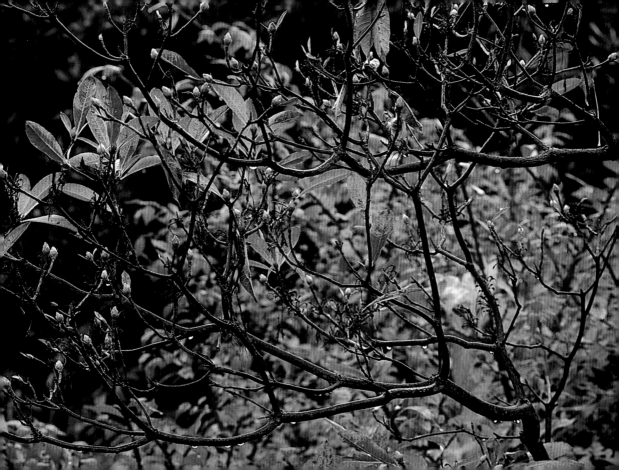

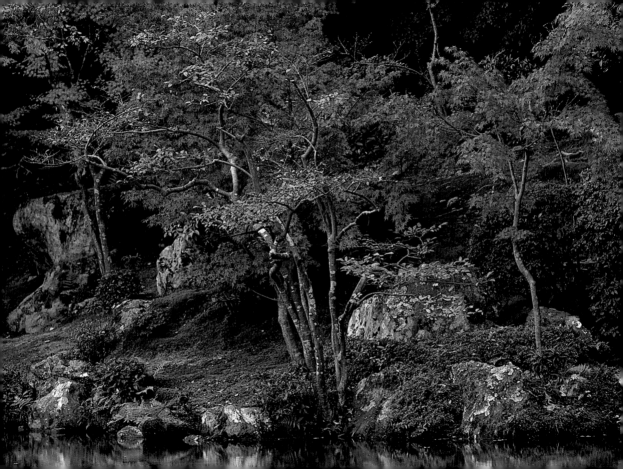

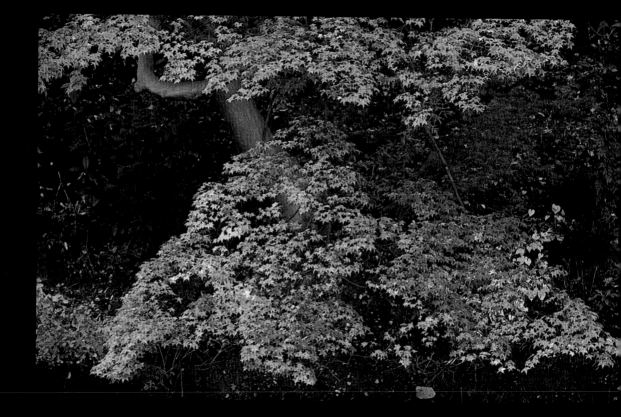

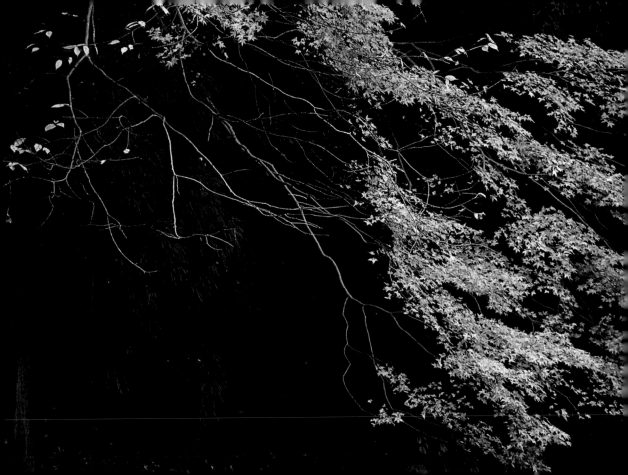

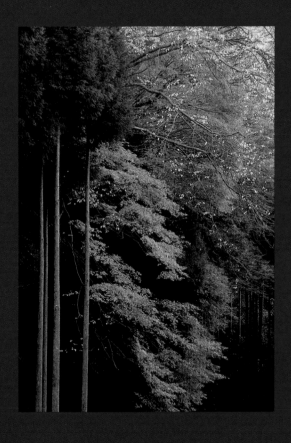

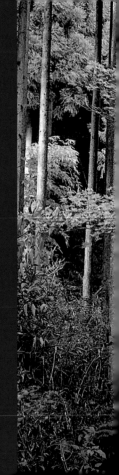

IN WILDNESS IS THE

PRESERVATION OF THE WORLD.

—HENRY DAVID THOREAU

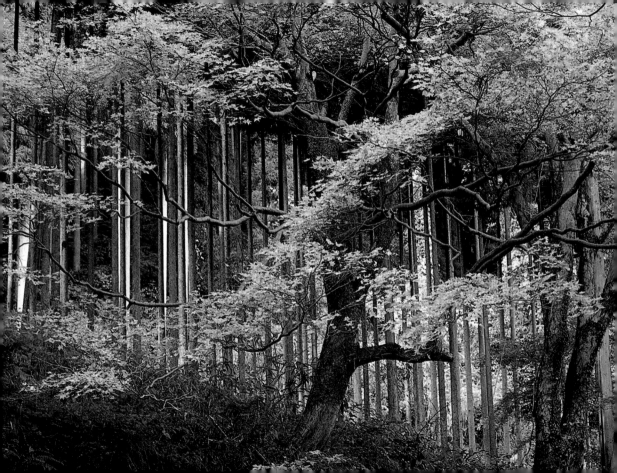

I BELIEVE A LEAF OF GRASS

THAN THE

IS NO LESS

JOURNEYWORK OF THE STARS...

— WALT WHITMAN

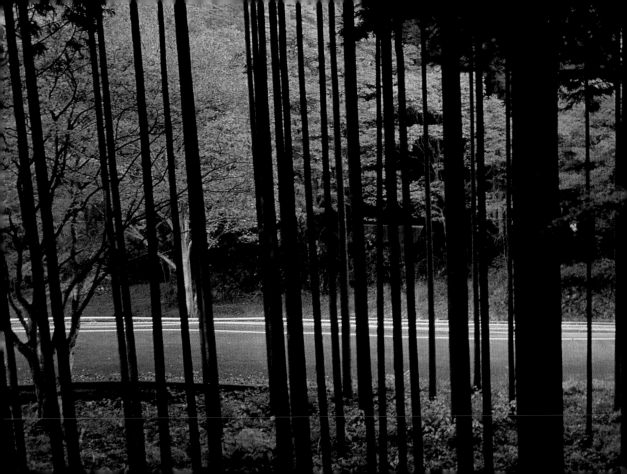

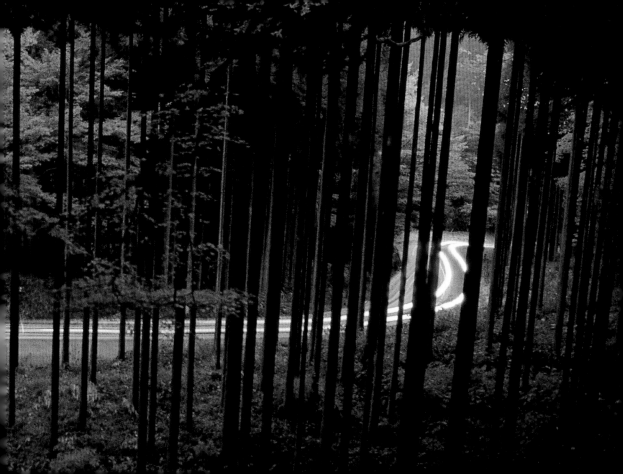

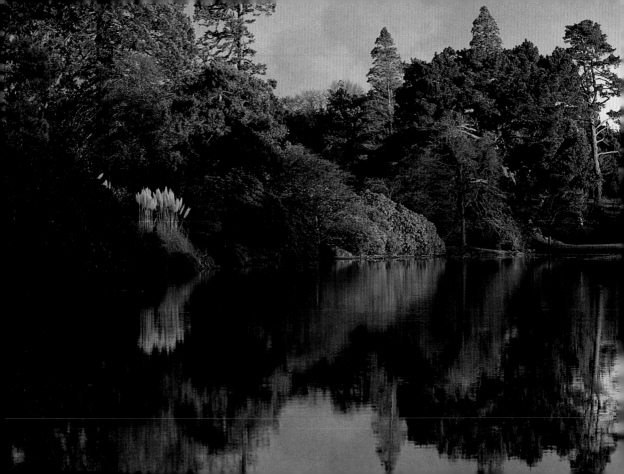

Surely there is something in the unruffled calm of nature

that overawes our little anxieties and doubts:

the sight of the deep-blue sky, and the clustering stars above,

seem to impart a quiet to the mind.

—JONATHAN EDWARDS

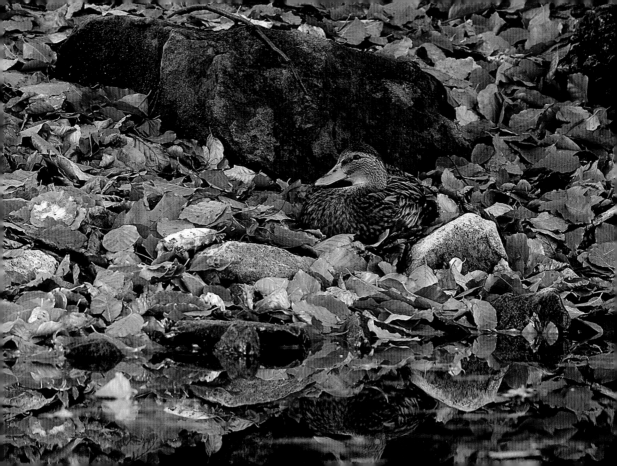

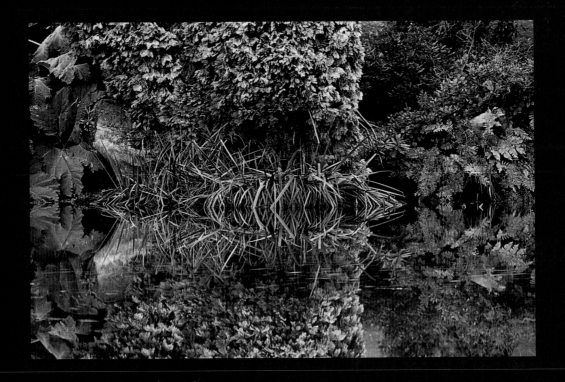

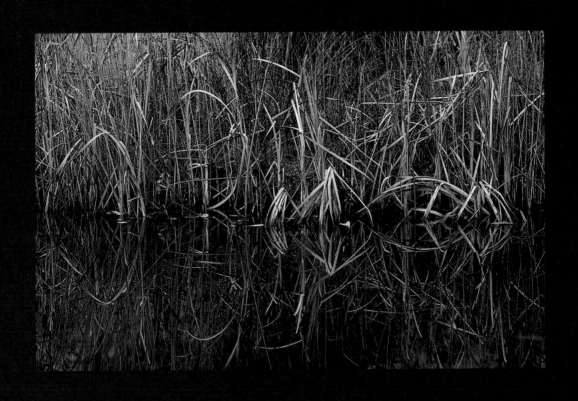

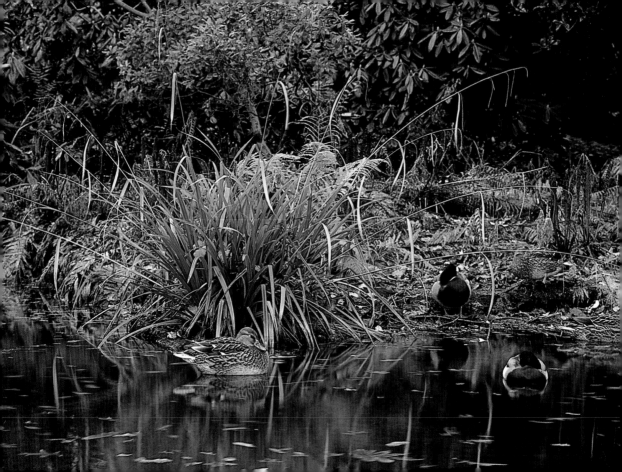

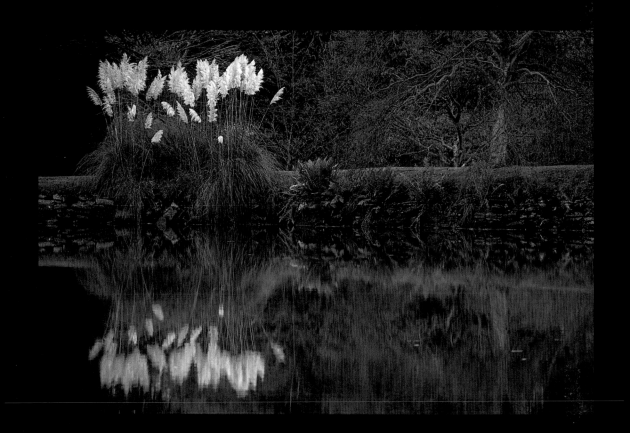

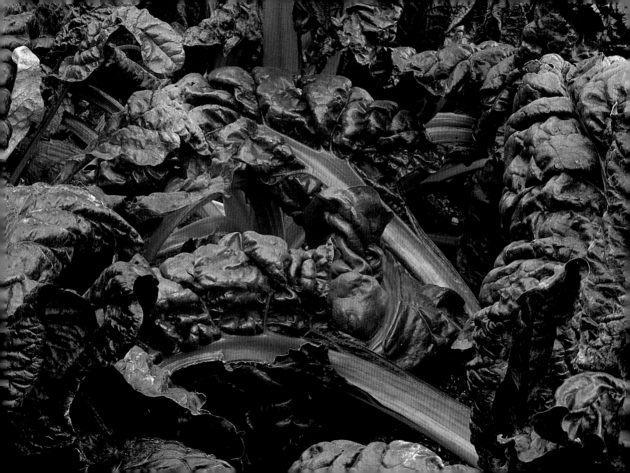

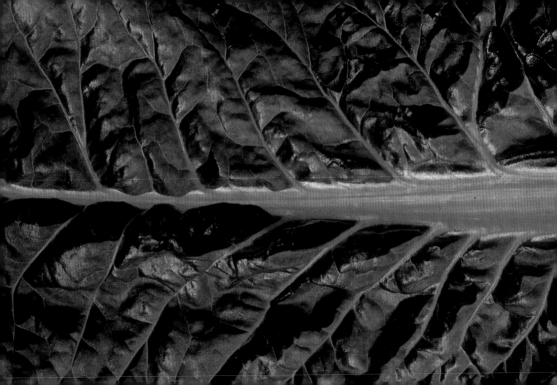

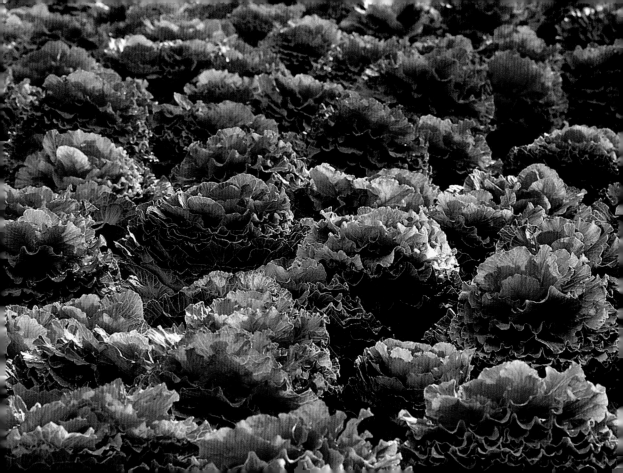

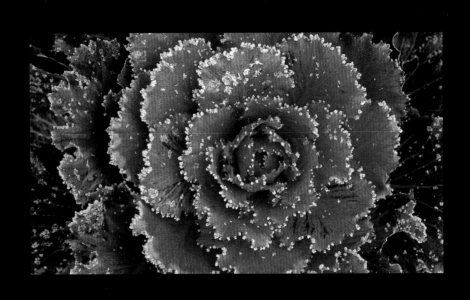

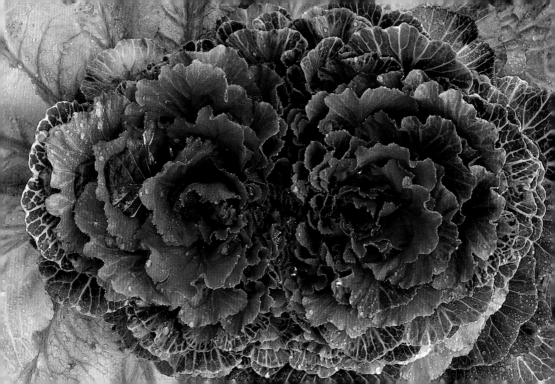

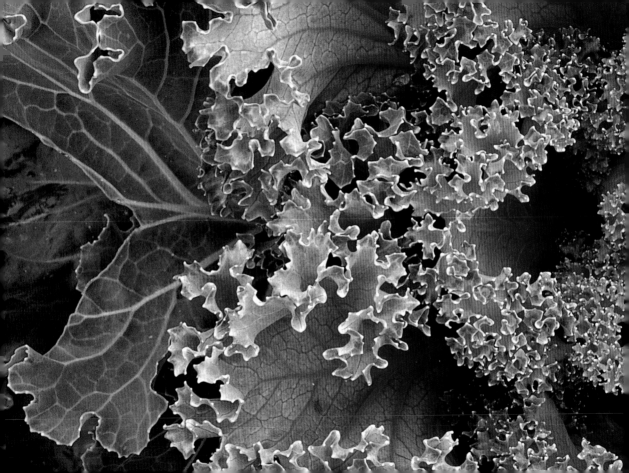

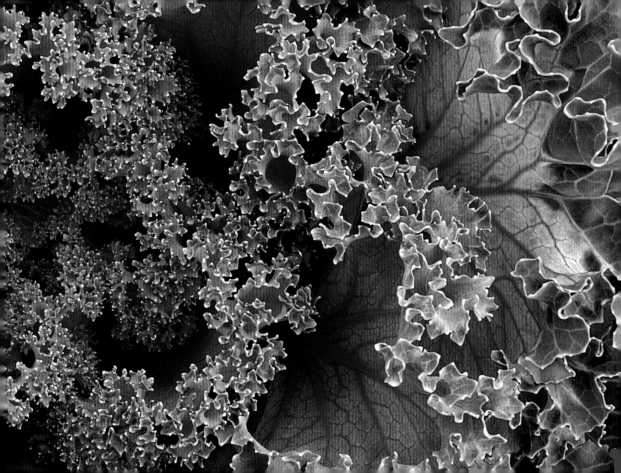

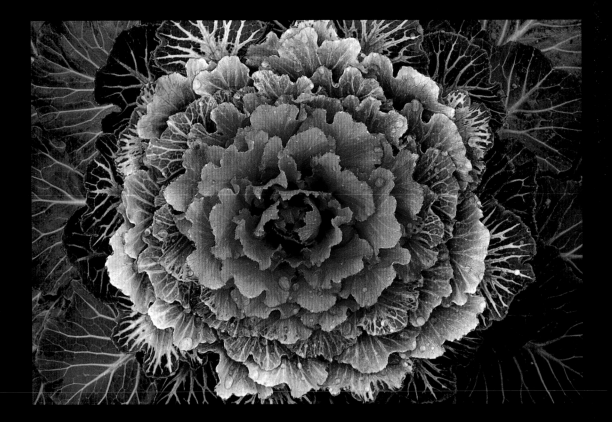

EVERYTHING IS GOOD

IN ITS SEASON.

—ITALIAN PROVERB

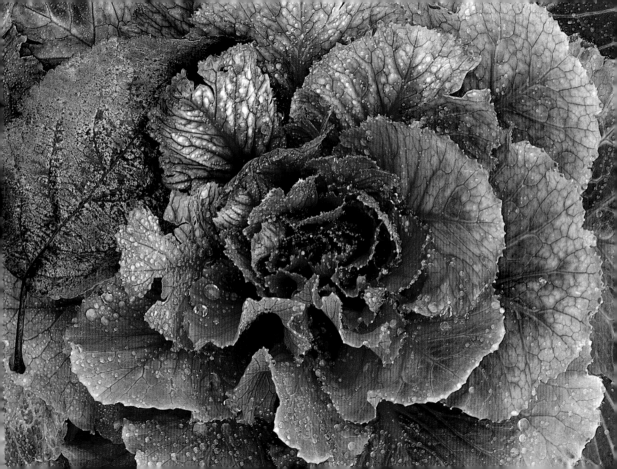

VITALITY SHOWS IN NOT ONLY THE ABILITY TO PERSIST,

BUT ALSO THE ABILITY TO START OVER.

— F. SCOTT FITZGERALD

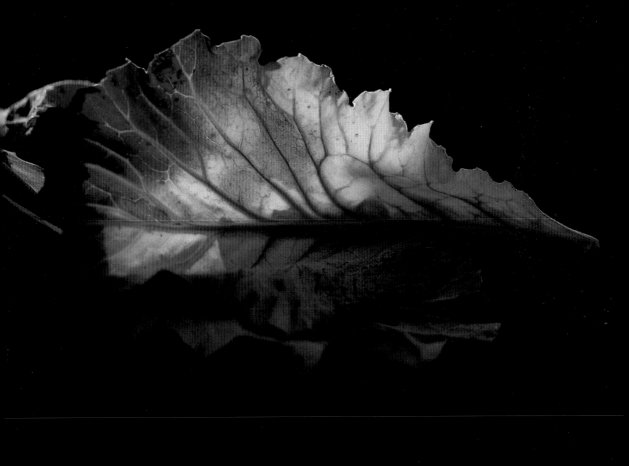

NATURE IS FULL OF GENIUS,
FULL OF THE DIVINITY;
SO THAT NOT A SNOWFLAKE
ESCAPES ITS FASHIONING HAND.

— HENRY DAVID THOREAU

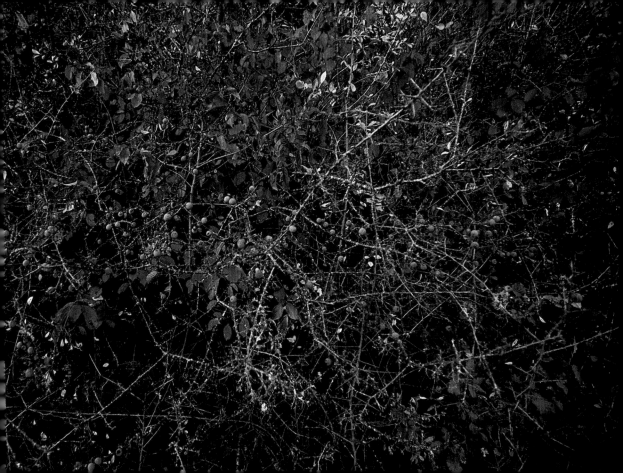

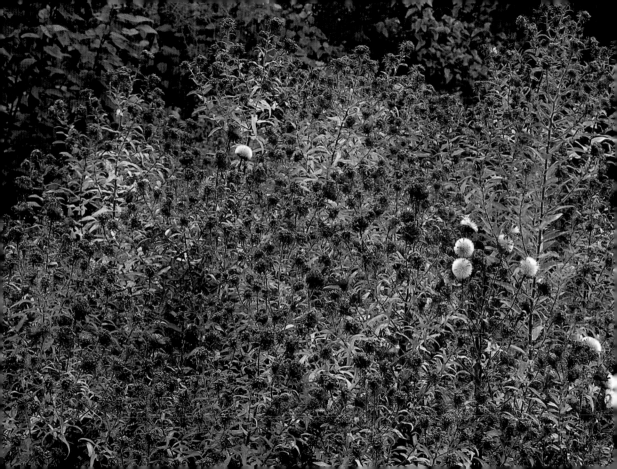

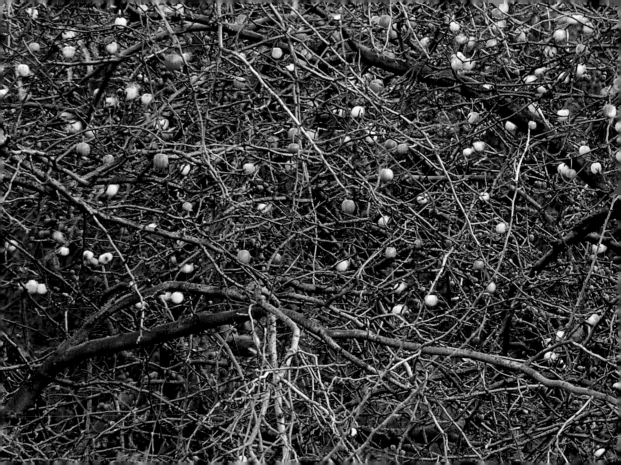

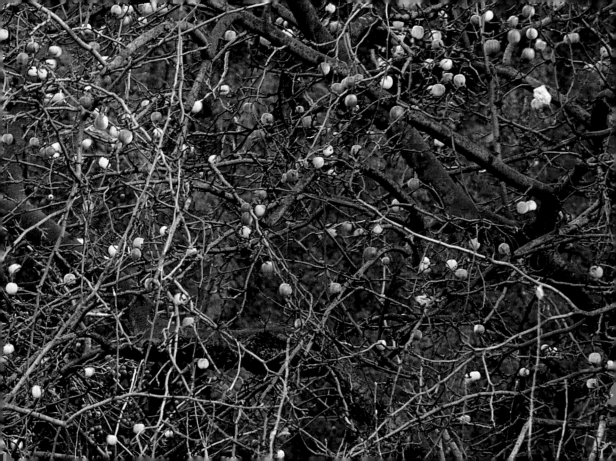

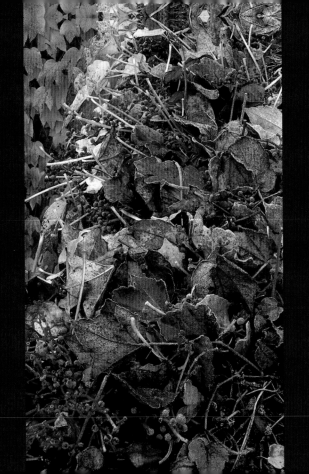

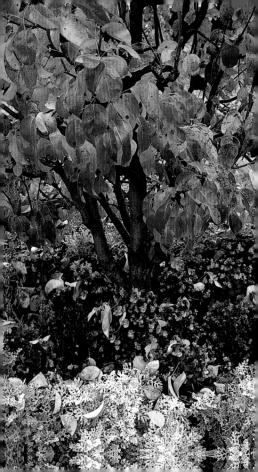

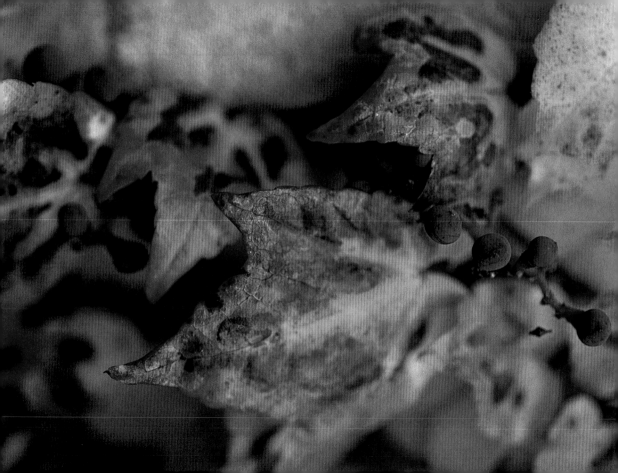

O NE PLUM GETS COLOR

BY LOOKING AT ANOTHER.

— PERSIAN PROVERB

172

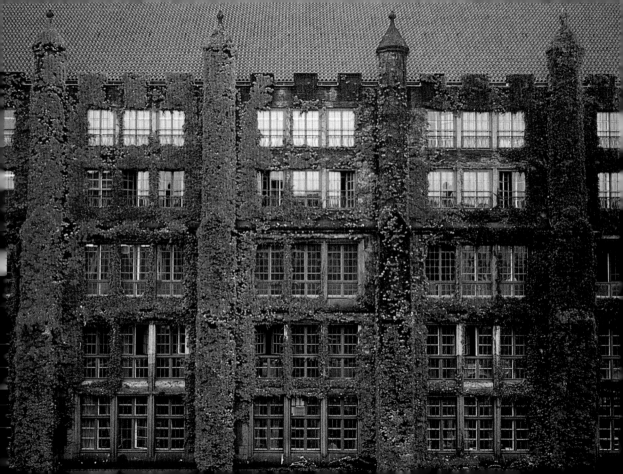

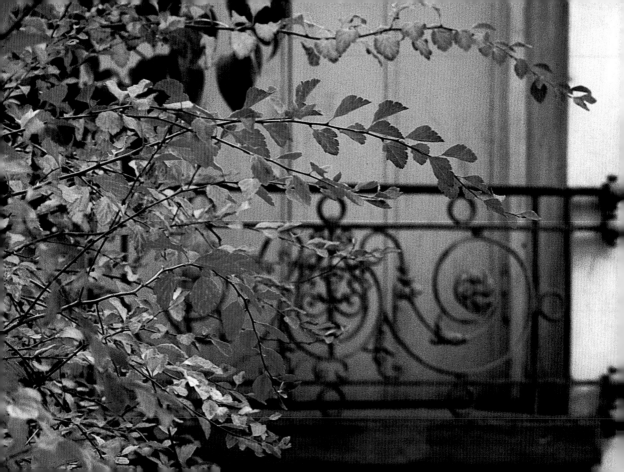

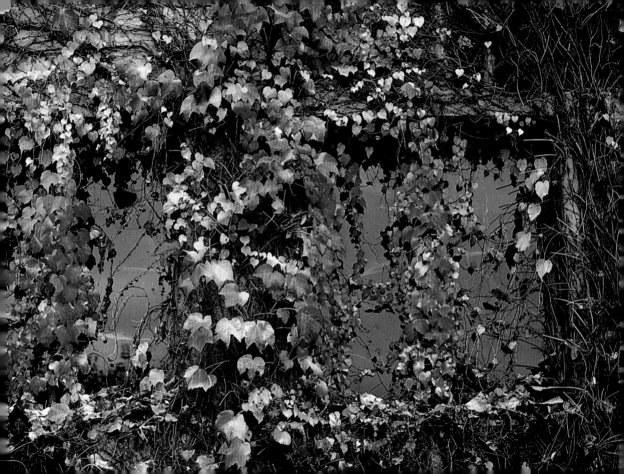

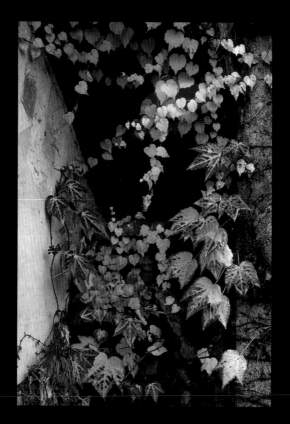

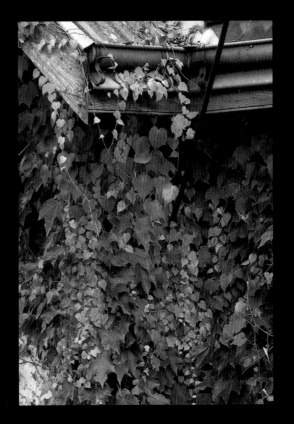

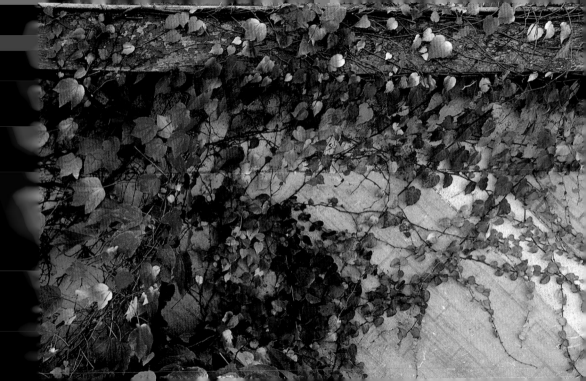

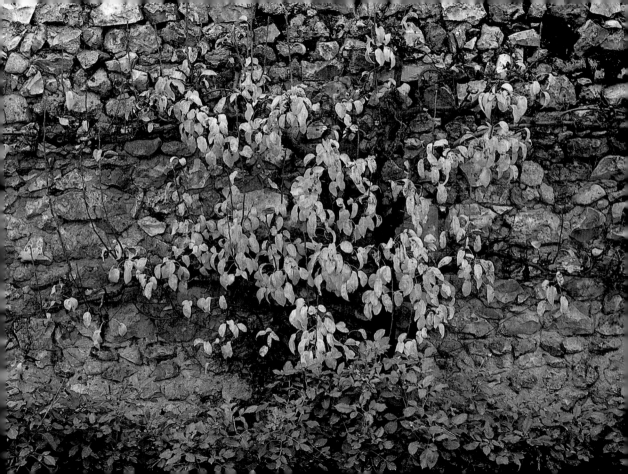

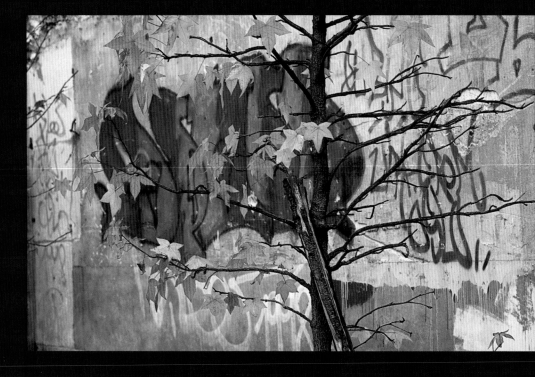

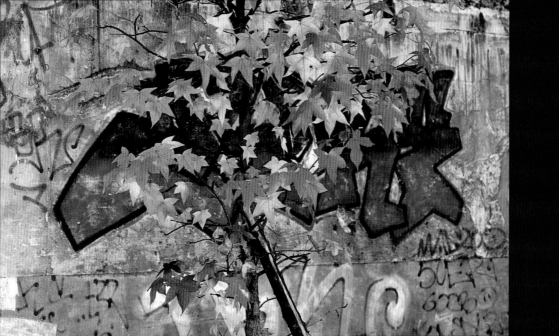

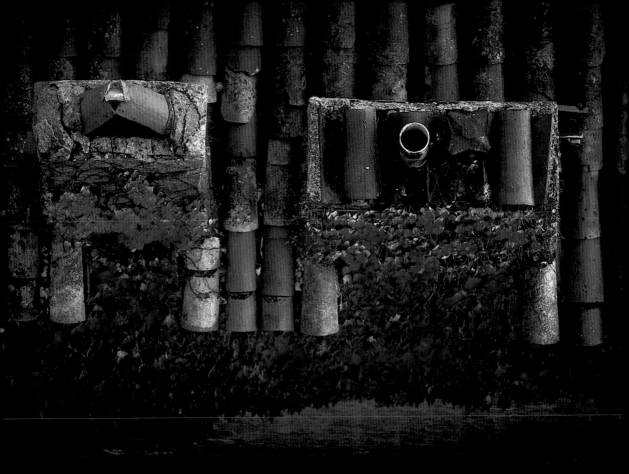

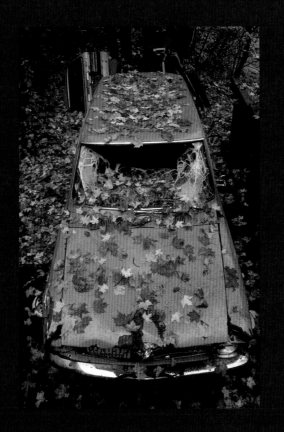

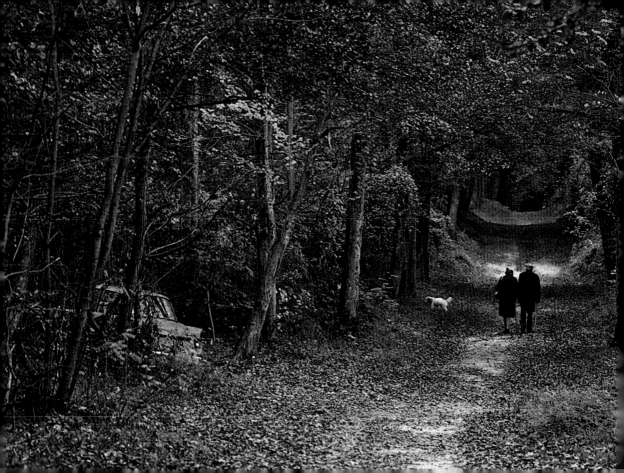

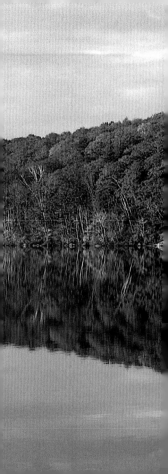

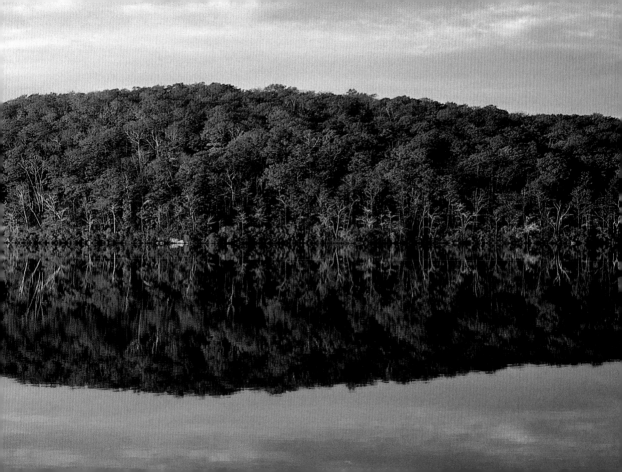

ALL THEY COULD SEE WAS SKY, WATER, BIRDS, LIGHT, AND

CONFLUENCE. IT WAS THE WHOLE MORNING WORLD.

—EUDORA WELTY

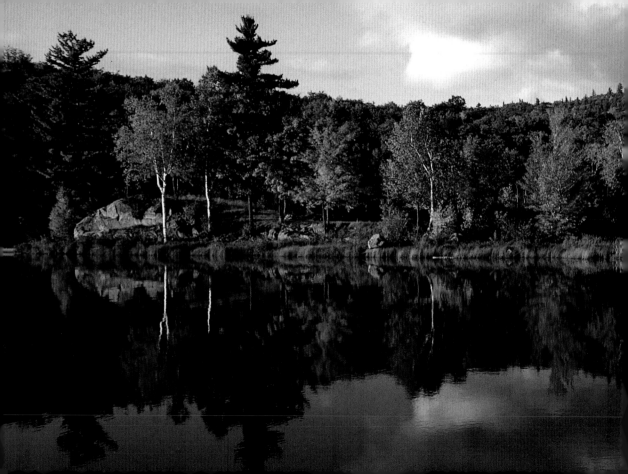

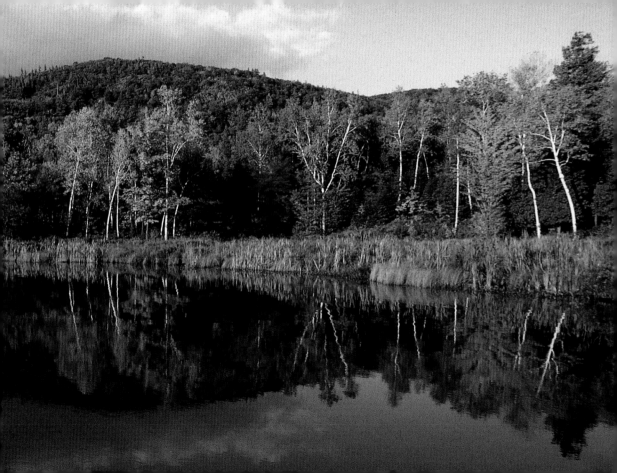

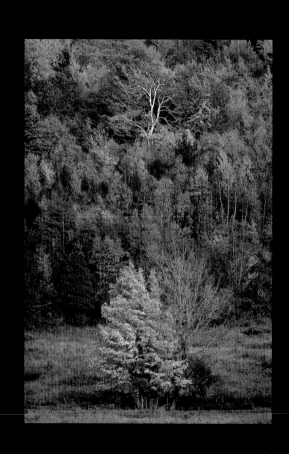

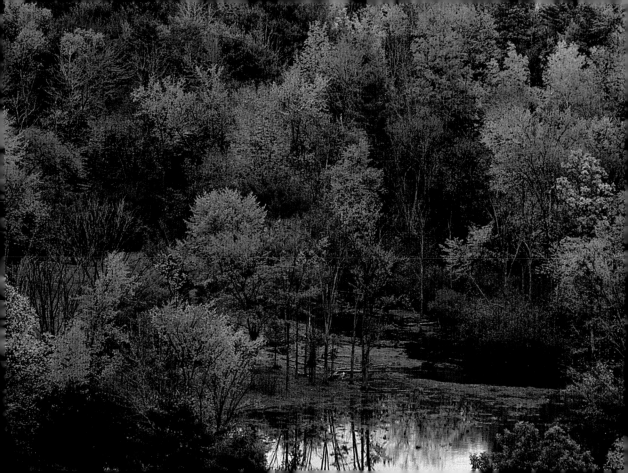

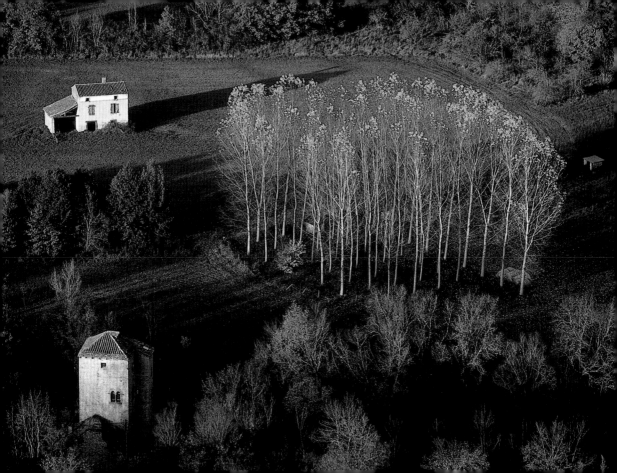

200

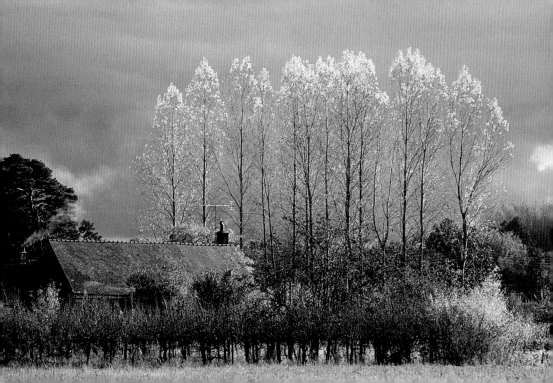

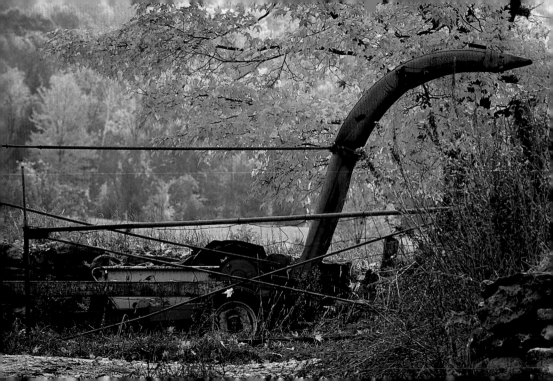

I saw old Autumn in the misty morn
Stand shadowless like silence,
Listening To Silence.

— THOMAS HOOD

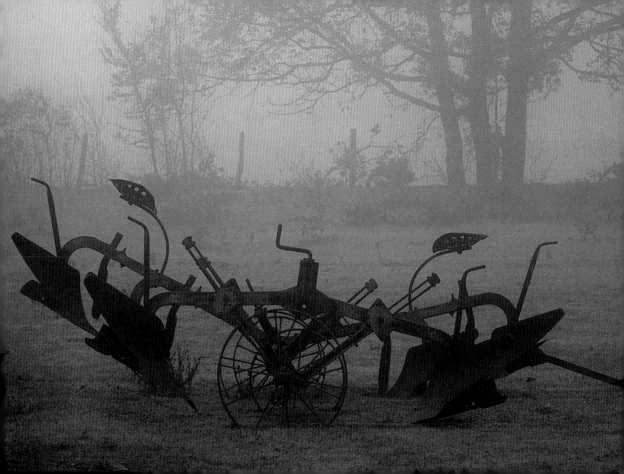

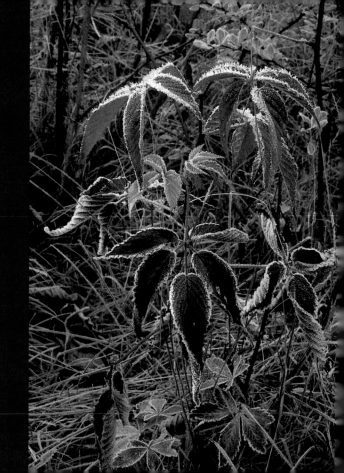

NATURE LOVES TO DO A GENTLE THING

EVEN IN HER MOST SAVAGE MOODS.

—THOMAS BAILEY ALDRICH

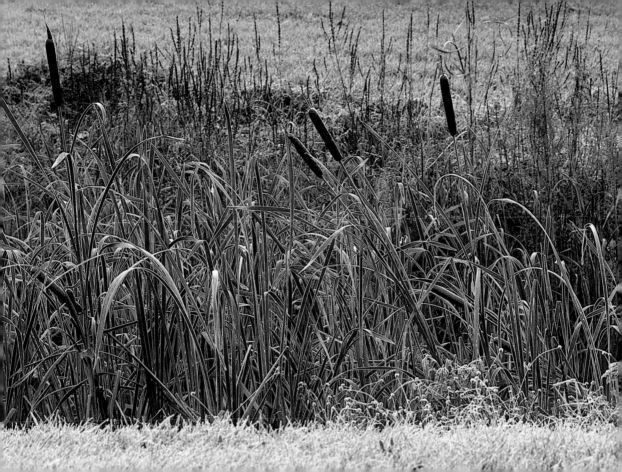

AUTUMN IS THE SPRING OF WINTER.

—HENRI DE TOULOUSE-LAUTREC

A LIST OF PLATES...

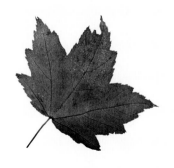

ACKNOWLEDGMENTS . . .

To Alain Cicerone,

without whose impetus this collection of photos would have taken
a lot longer to see the light of day,

and to Catherine & Coline;

Agha; France & Luis Ansa; Yann Arthus-Bertrand; Dolores Bentham & her family; Berggarten (Hannover, Germany); Elmer Bernstein; Pierre Bertrand; Éloi Bimont & Sandrine Huguette; Michèle & René Botti; Jean-Michel Branche; Marguerite Carvallo; Carlos Castaneda; Sandrine Chauveau & Bertrand Bataille; Jacqueline Danno; Bernard Denevi; Barbra & Mort Drucker; Pierre Dumoulin; Mother Earth; Chris & Jo Flamand; Jacqueline & Jean Fontaine; André & Liliane Franquin; Freeman Patterson; Lena Frias; Roger Gaillard; Anina Gardères; Véronique Garrigues; Gérard Jalbert; François George; Dr. Georg Gerster; René Goscinny; Yves Gourmelon; Michel Granon & his photo lab; Christophe Guebey & Sophie; Elise & Henri Guellerin; Ernst Haas; Margarethe Hubauer; Les Humains Associés; Gérard Issert; Kathleen Jayes; Paul Kepple; Regan Kramer; Kyoto's Tourism Office

(Japan); Frans Lanting; Janine Leguet; Shinzo Maeda; Bernard Mahé; Corinne & Robert Mallet; Mamie & Manette; Rolande & Claude Marin; Delphine Martin; Valérie Masset; Terri McLuhan; Steve, Neile, Terri & Chad McQueen; Charles Miers; Barbara Minty; Wolfgang & Hallenore Moller; Florence Montreynaud; Vladimir Moshnyager; David Muench; Dominique, Joy & Gigi Mulatier; Françoise & Maurice Mulatier; Benoît Nacci; Ellen Nidy; Michel Nion; Guillaume Met de Penninghen; Niki Picalitos; Jacq Péan; Josie & Lawrence Pearson; John Putnam; Connie & Peter Raffle; Patrice Ricord; Galen Rowell; Marie Sellier & Monique Salaün; Sheffield Park (Sussex, England); Georges Simonian; Archie Skinner; John Sturges; Melly Toussoun; Ada & Albert Uderzo; Villandry Castle (France); Michel Verdier; Suzy Wallis; Claire Wendling; Sophie de Wilde; Solveig Williams; Art Wolfe; Angela Yard...

AND TO ALL THOSE THANKS TO WHOM THIS BOOK EXISTS: WITHOUT THEIR ENCOURAGEMENT, THEIR PATIENCE, THEIR HELP—DIRECT, INDIRECT, SOMETIMES EVEN UNINTENTIONAL—THIS INEXHAUSTIBLE SUBJECT WOULD STILL BE JUST A DUSTY DRAFT ON THE SHELF. MAY I EXPRESS TO ALL MY WARMEST, MOST PROFOUND GRATITUDE, FOR THE MANY MORE AUTUMNS TO COME, GOD WILLING...

— JEAN MULATIER